490

6-95

THE ARTS IN A STATE

THE ARTS IN A STATE

A study of Government Arts Policies
from Ancient Greece to the Present

JOHN PICK

with contributions from Razak Ajala and
Malcolm Hey Anderton

Published by Bristol Classical Press

First published in 1988 by:

Bristol Classical Press
226 North Street
Bedminster
Bristol BS3 1JD

British Library Cataloguing in Publication Data

Pick, John, *1936-*
 The Arts in a state: a study of government arts
 policies from ancient Greece to the present.
 1. Arts. Policies of governments to 1987
 I. Title II. Ajala, Razak III. Anderton, Malcolm Hey
 700'.9

ISBN 1-85399-026-4

Printed and bound in Great Britain by
Short Run Press Ltd., Exeter, Devon

To Ann

We cannot revive old factions
We cannot restore old policies
Or follow an antique drum.

T.S. Eliot *Gerontion*

Contents

Preface

Anyone reading this book is likely to have certain beliefs about the relationship between governments and the arts. As the arts cannot exist commercially, governments *ought* to subsidise the arts. Moreover you can tell how decent and civilised a government is by the size of its annual grant to the arts world. Governments should recognise that the arts have considerable social and economic importance however, so they aren't simply throwing their grant money away; the arts are an important part of strategic social planning, they stimulate employment and high tourist spending within an economy. Moreover the reader is likely to believe that the social and economic benefits the arts bring are of benefit to the private sector as well as to governments and therefore the private sector should play its part in helping to fund what can nowadays reasonably be called 'the arts industry'.

These beliefs, which more or less encapsulate the general cast of mind of very many people concerned with both governments and the arts markets, have one thing in common. They all rest upon a wilful redefinition of what constitutes 'the arts', and upon an allied pretence that there exists one simple construct called the 'arts industry'. Hence each one of these beliefs, when tested against reality, is false, for both constructs are imaginary.

It is commonly said that 'the arts cannot exist commercially', but that is only true if you *define* 'the arts' as being those things which are in need of subsidy. In Britain virtually all publishing, most of the music industry, the largest part of the theatre, most of the visual arts world, the film industry, most crafts, the majority of the design industries and all that we call entertainment exists commercially. It is convenient both for hungry artists and power-hungry governments to pretend otherwise; the former for the good reason that there may well be a gap between worthwhile production of art and public taste catching up sufficiently for it to

have a market to sustain it, the latter for the rather less glorious reason that government subsidies are plainly a good way of controlling artists and art. (That motive is clear enough in the way governments so manipulate things that the media - which *could* often be sustained commercially - is forced by law to be dependant upon government license and government subsidy.)

Nor is the simple idea that 'the arts' have important 'social and economic consequences' worth very serious consideration, in spite of its liturgical reiteration in 'arts policies' all over the English-speaking world. There is no agreement in any case over what constitutes 'the arts'; different centuries, different countries, even different decades have different notions about what is or is not 'art'. Consider how each of the following has been both within and without the magic circle of 'art' in recent centuries - Needlework; Gardening; Cooking; Films; Jazz; Photography; Oratory; Dance. 'Art' has now become for most people a judgemental term, an epithet increasingly applied to what state bureaucrats want rather than what artists or critics judge worthwhile. And the multifarious economic circumstances which surround the production and presentation to a public of each of the dozens of different arts which actually exist - whether recognised or not by the new bureaucratic definition of art - are all smeared together as an 'arts industry', as if there are economic similarities in the way pictures, symphonies or poems are produced, which transcend their obvious differences. The notion of an 'arts industry' moreover assumes that the markets for plays, poems, pictures and operas are somehow invested with economic similarities. And it assumes that as a result of all this homogeneity certain economic and even social consequences inevitably follow upon the encouragement of 'the arts market'. 'The arts' (it doesn't apparently matter whether we speak of poetry or films or exhibitions or hip hop) will bind communities together, attract business ventures *and* of course bring in rich tourist spending.

As soon as it is put like that it is plainly too flabby a thought to be worth debating. *Some* poets, jazz musicians, film makers or whatever in *some* circumstances seem to bind their communities together; some produce work which leads to discord. *Some* arts markets for some of the arts seem to raise property prices; some arts markets depress them. The existence of *some* thriving arts may

be attractive to some businessmen; the presence on the other hand of a lively hip hop culture, high level graffiti work, genuinely alternative theatre or punchy reggae and soul groups may drive businessmen away. The risk in saying that 'the arts attract business' is that you come to define the arts as being only those activities which *do* attract business.

The danger in basing arts policies upon the acceptance of the new bureaucratic definition of art, and basing policies upon the glib assumption that there is something, readily perceived and understood, called an 'arts industry' is that 'policy-making' will boil down to being a simple question of how *the* 'arts industry' is to be 'funded'. Then all questions about the nature of creativity, about interpretation and criticism, about freedom and complexity, about diversity and choice, about value and about excellence will take second place to the supposed higher truths of economics. Policy-makers in the arts have been avid for simplicity in recent decades, redefining terms so that 'the arts' and such grand-sounding bits of jargonese as the 'the arts world' seem somehow to refer to the whole teeming complexity of art, but in fact refer to a narrow little bureaucratic construct - a world which is no longer subject to genius, creativity, interpretation and criticism, but simply economics. Bureaucrats cannot recognise or control genius or creativity, and they fear criticism, but economic forces they *can* control. Therefore art has to be seen as something which is 'like everything else', subject to economic laws.

It seems much simpler to believe, as Sir William Rees-Mogg has it, that the well-being of art simply depends upon the economic well-being of the nation. The notion even has a kind of shadowy truth in it, if you mean by art simply the arts markets (although even there, there is massive evidence that it is often as true to assert the contrary, that arts markets thrive when economies are in decline). But in reality the simple axioms lead us to great complexities. It may appear to simplify matters to believe that it is obvious what 'the arts' are, that there exists one simple process which we can call 'the arts market' and that (for example) it is true that the arts, if properly marketed, attract tourist spending and that therefore 'they' are worth investing in. In reality it makes things much more complicated - and the results of following a 'policy'

based on such bland hokum may as a consequence be quite different from those which were expected.

What does it actually mean to say, for instance, that the arts attract profitable tourism? First, it does not mean anything very precise. 'The arts' in a school curriculum has a different meaning from 'the arts' which are subsidised. But we can assume here it means those kinds of activities which government agencies currently invest in, or subsidise - national museums and galleries, opera houses, festivals, and so forth. Then, what is meant by 'tourists'? Plainly it does not refer to the poorer third of the British population, for example, because they never have holidays. It would not seem to refer to holidaymakers, because what they are attracted to is unsubsidised, and therefore not art. (The Regional Arts Association drawing up a cultural strategy which includes Skegness - a Lincolnshire resort which attracts thousands of holidaymakers - solemnly warned the citizens of the town that they were in danger of inhabiting a *cultural desert* which had no subsidised art in it at all!). It would seem that 'tourist' is an epithet which in this context is applied to rich people who take holidays which include visiting some government-sponsored site or government-sponsored events. The notion that 'the arts attract tourists' which may appear at first sight to be an appealingly broad truism then boils down to something like 'The comparatively rich and privileged often visit government-sponsored activities during their holidays'. The term 'arts' and 'tourists' are *both* judgemental, each helping to define the other, so that a statement such as 'the arts attract tourism' which seems to be an empirically-based generalisation, is in reality no more than a tautology.

What *is* the empirical evidence, at least as regards Britain? First, Britain isn't particularly attractive to tourists. 8,000 Europeans in a 1986/7 Travelmeter poll rated Britain second bottom (equal with West Germany) as a desirable tourist location, only 8 per cent of those asked saying that they would like to holiday there. And of those who do holiday in Britain only a few would apparently count as tourists by the definition above, for a list of the most popular paying attractions to holidaymakers includes very little that has to do with the subsidised arts.

Britain's top ten paying attractions

Madame Tussaud's, London	2,400,000
Alton Towers, Staffordshire	2,200,000
Tower of London	2,000,000
Magnum Leisure Centre, Irvine	1,300,000
London Zoo	1,200,000
Kew Gardens	1,100,000
Duthie Winter Gardens, Aberdeen	1,100,000
Drayton Manor Park, Staffordshire	900,000
Jorvik Viking Centre, York	800,000

More disturbingly, it would appear that the subsidising of the arts actually helps Britain towards a *loss* in its 'tourist trading' account. Since 1981 the British have spent more abroad than visitors have spent here, and the gap is steadily widening; in 1982 it was £466,000,000; two years later it was £1,062,000,000; and now it looks like being more than two billion. An important contributor to this is the AB social group that has its enjoyment of the domestic arts heavily subsidised, so that money is released for it to take an increasing number of overseas holidays and spend money on the Chateau of the Loire, the Italian opera, Spanish Festivals and Greek museums.

In other words, even a cursory examination of any precept based upon the bureaucratic notion of 'the arts' and upon too simple-minded a belief that the only real problem is 'funding' them, will lead to trouble. Only a tiny part of the total arts world attracts holidaymakers, and if you dignify that segment with the title 'tourists' and start making it a basis for policies, you may well find that you are doing harm (first of all) to the arts economy. By keeping theatre prices low to attract Americans, for example, you may be contributing to a financial drain as the majority of your audience is now free to spend a greater part of its wealth overseas. More importantly you may of course be doing untold harm to art itself, for the desire to attract tourists may well carry with it a desire to play down to them. The programme may become bland and stereotyped; you may lose the interest of new and innovative artists, of your domestic audience and in the event may even lose

the tourists' interest as well. It is therefore as true to say 'The arts lose by tourism' as its opposite.

That is one small illustration of the general theme of this book, an argument that our 'arts policies' are often at best political constructs, thinly disguised control systems which rely upon the persuasive redefinition of many arts terms to make them seem both benign and credible. We shall throughout the book question whether 'arts policies' as such are either desirable or indeed possible to have - and we shall give many examples of such 'policies' which neither make sense nor can they be used as a basis for action. To do this it is necessary to look (albeit quickly) at some of the historical shifts there have been in the relationship of governments and the arts, largely to dispel the notion that the only involvement of government in 'the arts' is through its subventions to arts markets. As we shall repeatedly say, the percentage of GNP which a government chooses to give in grant-aid to the arts is no real indication of the government's civilisation, nor of its generosity of spirit. The amount of money governments give to the arts is on its own no indication at all of the true nature of that government nor of the culture it represents; the most liberal and democratic of governments in the twentieth century have given little and had no arts policies; the most vicious and inhuman have had arts policies, regional strategies, arts officers in post and have been extremely generous towards their opera houses, museums, galleries and their concert halls.

We shall repeatedly return to the pervasive fallacy of government-inspired arts policies - that belief which is currently everywhere in the advanced world that 'the arts' are an industry, and nothing more. Therefore arts policies are only real when they are economic policies, and artistic aims are therefore necessarily subordinate to managerial aims. Here are two quotations about the market place, and its importance:

> The arts are in competition with many other things in the market place, competing for the customer's time and money, and marketing the arts attractively and forcefully must be our absolute priority.

> If your goods are to be sold...your package is fighting for you against every other package directly or indirectly competing. You cannot expect it to get much help...from the people running the shop.

The first is a senior member of the British Arts Council, speaking in 1985, the second is the Chairman of Unilever, talking to his shareholders about selling soap in 1965. It is significant that both are more or less saying the same thing - that nothing matters except the market, and that sales will be affected by the design and packaging as much as by the product itself - and it is significant too that there is a twenty-year gap between them, for the catchpenny notions of economics and management which arts bureaucrats have are nothing if not well-worn.

The arts are not an industry (above all not *an* industry). They are not goods or services either. They belong, in their great variety and infinite complexity, to other realms. The many markets for the many arts are of course affected by government economic strategies, as legal changes affect artists and their search for audiences, but a policy for the arts must take into account very much more than how you are going to finance the government-supported activities. An arts policy must look at the history which has formed the national cultures, must look at the legislative and fiscal frameworks within which each of the various arts has existed, must look at the history of the language to inquire what is actually *meant* by the culture, the arts, the arts markets, arts education, cultural diplomacy, tourism, development, progress, excellence, provision, access, wants, needs and all the other key words that pepper the arguments. It must be recognised that an arts policy can be a policy of control, can propound a disguised system of censorship or standardisation, or can be meaninglass claptrap disguising an official vacuity - an ignorance about the answer to the question which seemed to the Greeks self-evidently to be at the heart of any policy discussion; how should the state so organise itself that each person can live well?

This book is mine, but I am conscious of many people who through their own teaching, through long discussion with me or through other means have contributed much towards my own thinking. In particular I owe a debt to Dr. Michael Hammet, whose work has established policy studies in my own University and to whose constant rigour I am indebted. To many people in the arts bureaucracies themselves I owe a debt, not least for their kindness in continuing to debate with me even when I am apparently,

through some kind of wilful malice, advocating that the bureaucracies which they illuminate be disbanded forthwith. In particular I recall seminal conversations with Peter Stark, with Vivian Nixson and of course with Professor Tony Field. I have been constantly refreshed and helped by my own research students, in the present instance by Ms Christine Horn, Dr Howard Hughes, Ms Celia Larner and Dr Paul Bisson. As always, Dr Robert Protherough has been refreshingly candid about his views of those opinions which I have discussed with him, and I have enjoyed the regular critique of my colleagues Eric Moody, Michael Quine, Dr Caroline Gardiner, Freda Steel, John Elsom, Professor John Last and Professor Charles Arnold Baker.

I am particularly grateful to my collaborators, Mr Razak Ajala and Dr Malcolm Anderton. Each has contributed much material, on arts policy-making in the third world and performing arts management respectively, and has kindly allowed me to make my own use of it. In addition each has offered comments and criticisms of other sections of the book, and I have found their cooperation invaluable. However the main arguments of the book are entirely mine, and I am responsible for all errors of fact, infelicities of style and for all warped judgements the reader may detect. Naturally my hope is that there may be virtues enough to outweigh all of these.

John Pick
City University
1988

THE PAST

1: The Greeks and the Romans

At one extreme, it is perfectly possible to believe that artists and governments should have nothing to do with each other at all. That was the view adopted by Dr Banfield, in *The Democratic Muse* 1984. His study of the policies of the various funding agencies in the U.S. led him to a trenchant conclusion:

> The regime exists for purposes that are not served by art, and the support of art is not among the powers that are given to the...government. None of the agencies under study has a defined purpose in any proper sense of the word, let alone one arrived at with knowledge and deliberation. What passes for purpose with each of them is a set of vague and conflicting statements of good intentions based on gross misconceptions of the nature of art and of the amount and character of the public demand for it.

Modern fashion however takes a different tack. Governments and political parties are nowadays expected to have policies, and to discuss 'the arts' as if they were a quantifiable part of the national economic wealth, or an accountable public service. Nowadays it is the fashion to write 'arts policies' as if they were exactly like policies in other areas, and as if the creation of art and the benefits that may accrue from it were both simple to comprehend, and readily susceptible to government control and 'support'.

The belief that it is possible to have such a thing as an arts policy, and the determination that governments of all kinds ought to publish such things are both recent beliefs. In the great classical civilisations of Ancient Greece and Rome no such discrete policies exsisted, and indeed, right up to the middle of the twentieth century the British had looked with disdain upon countries which had some form of centralised cultural policy. It was to be either the kind of repression totalitarian governments went in for, or (in the case of France) a sure sign of cultural sterility.

Indeed, until recently there still hung about the word 'policy' some of its older associations - to have a policy was to be cunning, sly, deceitful. The post-war British Arts Council, when announcing that its policy was to have no policy was reasserting a long-held belief that cultural matters were rightly the province of the amateur - the cultivated lover of the arts who would scorn to use deceit and trickery, and hence would scorn to sully his attitudes by describing them collectively as a policy. 'The arts' were in any case not seen as being in a separate compound from the rest of our lives. As recently as 1951, when the great post-war Festival of Britain exhibition was assembled on the South Bank in London, although many artists, poets, sculptors, musicians, architects and designers contributed to each of the exhibition's 27 pavilions, there was not (as there would be today) a separate pavilion for 'the arts'. The catalogue makes none of the claims that would nowadays be made for the social, educational or economic effects of the arts; they are just assumed to be worthwhile in themselves, an integral part of a full life, to be celebrated not by any supposed social or economic benefit they may bring, but simply because they are good. 'It soon became evident,' says the Festival's catalogue, 'that the Arts would be best displayed in a series of country-wide musical and dramatic performances and special exhibitions.'

Nothing so straightforward would suffice in modern Britain. 'The arts' are not seen as being displayed to their best advantage by simply enjoying them 'country-wide'. They are best displayed as agents of social welfare, cementing community values or giving a hearing to an ethnic minority, or they are best displayed as economic investments bringing wealth to the inner cities; they are goods or services, and of course the apparent objects of government 'policies', just like health, housing, or national armaments. The production of art itself has been increasingly complemented by the production of all the paraphernalia of policy-making - discussion documents, reports, assessments, position papers, strategies, inquiries and investigation - which has at times threatened either to suffocate the actual art which it purports to describe, or has excited such general interest that it has in a curious way sometimes itself seemed to be a substitute for art.

The bureaucracy also becomes a substitute for the entirety of a national culture. Until the nineteenth century the word 'arts' in

English had referred to all of those things which gave anyone benefit or pleasure, whether they were performed by professionals or amateurs, in the privacy of the home or in public, with or without an audience or onlookers. 'The arts' referred to a range of skills, from the ability to join in the conversation in the local tavern to building a pleasant and functional cottage. And just as most citizens in the widest sense of the term enjoyed the arts, so most citizens participated in some degree in those evaluative processes which estimated their worth; there was in Britain in the eighteenth century a common participation and understanding of creative activities which could rightly be called, with the precise emphasis the term suggests, *common sense*. Then in the nineteenth century that common sense flew apart. 'Art' separated itself off from crafts, from design, from sport, from pastimes and from entertainment, and became something which professionals did, and which could only be comprehended by an educated minority. Common sense was replaced by the internal machinations of élitist critical salons, and in spite of all the cries for art to be restored to the people, it became obvious that in the new sense of the term it could not be done. 'Art' was no longer a descriptive term, including all the myriad creative activities which in total were the national culture. It was now a judgemental term, putting a particular value upon one special part of the entirety of the culture.

And the judgement as to what was or was not art passed from the common sense through the critical schools to the hands of bureaucrats; politicians and their minions who now decreed what was and what was not to have a high value put upon it, and whose machinations became themselves of as much interest as the 'art' they licensed and financed. In the twentieth century there were Arts Ministers, Arts Ministries and Arts Councils who increasingly plotted in private while putting out policy statements saying they wished to return 'the arts' to the people. As a consequence people began to refer to 'the arts' as if they actually *were* the bureaucratic processes. A newspaper headline saying 'Crisis in the Arts' no longer referred to any problem writers, muscians or painters might be having; it always referred to some political or financial problem, always of the bureaucrats' own making, but nevertheless vaguely blamed upon 'the nature' of art.

Artists increasingly found themselves, somewhat paradoxically, excluded from the inner recesses of the 'arts world'. And they found themselves too curiously cut adrift from the countries which had nurtured them, for artists, like art, came increasingly to be seen as an international currency, a coinage with a variable exchange rate fixed by the new arts bureaucrats. They were seen less as valuable citizens, worth having in themselves, than as potentially useful exports, or as tourist bait. It does not seem to matter whether the artists now in any real sense belong to their host country at all, or whether there is any kind of sense in which the community that nurtured the artist and the artist are still in touch. The relationship between how most people live, and the world of 'the arts' has been severed. The older meaning of the term is now denigrated as *popular* arts, and everybody now is led to believe that what is art is a matter for the new secret bureaucracies. When they have decided what it is they will import it and inject it into their towns and cities and organise it so that it lures rich tourists in to spend. They will also sometimes use public funds to keep seat prices low enough to bribe a few people in from the immediate locality, but *their* attendance is increasingly less important than the well-to-do visitors who, when they are on holiday and reclothed as tourists, spend more.

In the classical civilisations the artists were prized as *citizens*, not as tourist bait. When the work of artists attracted visitors to the festivals, it was welcomed, but their prime importance, domestically and abroad, was as leading citizens and diplomats. As cultural messengers they were always known by the name of their parent state, and were seen as representative not of some economic master plan but of the whole of the citizenry. They had earned the general plaudits of their fellow citizens as the best musician, the best actor or the best dramatist (had been valued as a result - in a word - of a common sense). Their fellow citizens *wanted* them, *wanted* to hear their work, *wanted* to be represented abroad by them. The population wanted moreover to hear their views on how people could best live their lives, and on how the state should organise itself so that they could do so. Artists were at the heart of political debate, not excluded from it.

People's *wants* are now reviled and scorned. The bureaucrats use another word instead, needs. In its modern usage people's

needs, particularly their *real needs*, are things which only bureaucrats can discern. Not surprisingly, people's real cultural needs often turn out to be for the activities the bureaucrats have designated as art. But in a modern state this has nothing to do with cultural traditions, with what the majority of people want, or with what gives benefit and pleasure to the majority. Nor is it any longer much to do with what the state's own artists do, or with what critics say. It is a strange bureaucratic construct, an economic unit that has a general international currency - not the common pleasures, nor the indigenous artists and art, nor the links between them. This is a pervasive new concept, as new as 'arts policies', which invites us to think of 'art' as somehow separate, an entity apart. Yet we cannot think of the genius of Plato, of Sophocles, of Homer or Terence, of da Vinci and Shakespeare, of Goëthe or of Tolstoy without reflecting upon the civilisations which nurtured them, and without knowing the cities and the states in which they lived. That profound question, how should the state so organise itself that its citizens may best live their lives, is asked not only in *The Republic*, but in *Hamlet* and *Faust*, is asked and answered in all great writing. Recognising that question is being asked is one of the reasons we have for calling some books great.

When the question is not being debated or when (as in our own time) there is assumed to be an easy answer (that governments in the modern world must control artists either by political force or economic pressure), we tend to think the whole civilisation is diminished; its freedom illusory and its wealth ill-gotten. It is the fact that the state's only response to *The First Circle* was to ban it that causes us to reaffirm our belief that the Soviet Union under Stalin was a vile place. On the other hand our view of Athens is hardly diminished by the astringency of its censorship laws, or even by the fact that Socrates was put to death for his teaching. We believe it to have been a fine civilisation because of the intense and nervy debate, forever open to modification through experience or through pure argument, which permeated the lives of Athenian citizens. The most important question civilised beings can ask was placed where we feel it should be, at the centre of life. In Stalin's U.S.S.R. the question was presumed to have been answered, in final and coarsened terms, so the debate had been buried, and with it hope. Yet Greece had laws for its citizenry almost as draconian

as those of the Soviet Union, it treated its subject races no better, and it had no hesitation in putting enemies of the state to death. Its treatment of women and slaves was sometimes worse than in Stalin's regime, and though more favoured in its natural resources, its citizens were more arrogantly assertive of their own prowess. In spite of all of that, we take the ancient civilisations, and in particular the city state of Athens and the later might of Rome, to represent infinitely superior civilisations, not by virtue of their notions of social justice, or even by virtue of the artists they produced, but by virtue of the openness to debate. The subtlety and maturity with which the voices of government and artist were each considered and given due weight, in every realm of public and private life, seems to us to make those civilisations, without qualification, superior.

It will seem surprising to many people, to assert that it is not justice, nor freedom, nor equality which distinguishes our view of those peoples, but rather their openness to rational argument, their willingness to be a part of a nervy dialectial process which makes them superior. Yet it is so. Athens met hardly any of our fashionable notions of what a superior civilisation should be. It had no separate arts policy, nor did it have a single term for 'the arts'. Its society was manifestly class-ridden and even its citizens had far from equal access to education, its music, its entertainment and other pleasures. Its women were second class citizens, and its religions were primitive, and of rural origin. The roles of citizen, politician and manager were not in the name of some notion of specialised efficiency, separated, but bound up together in a single notion of what it was to be Athenian male. In the mines a tortured and confined multitude of some 14,000 slaves hacked out the marble for the city's great buildings.

Thus the Parthenon, the greatest of the public works by Pericles, was built on what Lewis Mumford in *The City in History* calls 'blood money'. It was made possible by the Athenians' wholesale sacking of their conquered neighbours' cities, a hideously cruel process which involved such atrocities as the extermination of the entire male population of the surrendered city state of Melos. Though the admired *poleis*, the city states with their emphasis upon reason and debate, were a celebration of a new humanism, a belief in man's innate powers to live life well,

there was yet an extraordinary blindness to social injustices, to cruelty perpetrated upon others, and an extraordinary self admiration, a narcissism that eventually turned the debate between the political realm and the artistic realm to stone. As Mumford observes:

> The worship of the polis, enthroned in myth and legend, wrought in costly architectural works, replenished in a succession of enchanting rituals, had an insidious effect upon the city. What began as collective self-respect, confident of powers tested under external pressure, turned into the worship of a frozen image of the communal self. In the end the polis was undermined and met destruction by its over-commitment to the arts and rituals that had fortified it in defeat and celebrated its successes. Well did Plato observe in The Laws that the greatest plague of the city was 'not faction, but rather distraction'.

The state is here destroyed (as in its turn Rome was destroyed) not by its desire to destroy its internal critics, its divergent artists and its talented creators, but rather by its decreasing willingness to debate, its increased laxity towards its creators who in their turn became slackly adulatory of Old Athenian virtues.

Again, this account of events will be difficult for some modern readers to accept. We have grown used to equating the financial support to 'the arts' by government as a good indication of that country's civilisation. We are told Britain should be ashamed of itself because it spends a lower percentage of its gross national product on arts subsidies than does West Germany, or - with even less justice - that the U.S. is plainly less civilised than Britain because its National Endowment for the Arts has a proportionately smaller budget than does the British Arts Council. Yet in truth there is no relationship between what a government spends upon the arts and the quality of life or the artistic products of that country. Hitler's Third Reich, Mussoloni's Italy, Stalin's U.S.S.R. all spent proportionately more upon the arts than Britain, Canada, Australia or the U.S. now do, but we would surely not take that as conclusive evidence of their superiority. A country must be judged more by the quality of the debate between government and artists, and by the nature of the constraints it places upon artistic expression. For governmental *constraints* upon the arts, of all kinds, are almost

always of much more significance than the systems it may have for 'supporting' them.

At its height, Athenian civilisation held in balance the two great purposes of the arts, inspiration and criticism. If the work of an artist, or even a musical instrument, could be shown to have too bland an inspirational effect, or, like the flute , could be held to stir only the disruptive passions, then it could be banned. (Plato did indeed argue for the banning of the flute.) Great art both inspired and questioned the ideals of Athenians. At the great festivals obeisance was made both to Apollo, the god of pure idealism, and to Dionysus, the god of revelry, lust and revolution. In the arts therefore the twin natures of man were held to be reconciled.

When Athenian civilisation waned, the state veered towards the promotion of inspirational, Apollonian art; what was commissioned was laudatory of the past, it repeated stereotyped notions of good conduct, and questioned little. The arts thus became decorative, unchallenging, and the dialectic collapsed into ritual and inertia. The state's policy towards the arts, by the fashionable modern view, was improving all the time, but all that was happening was that state funds were being passed, without the necessary astringent debate, to artists whose contribution became then as lacklustre as that, in a later debacle, of the Emperor Nero. In their different ways, the endings of the two great classical civilisations thus give us two kinds of warning. It is unwise of the state to encourage *only* the promotion of art which glorifies the fixed ideals of the state itself; the dialectic between inspiration and criticism gives the arts their central significance in public life, and when the Athenians ceased nourishing that necessary conflict, arts and the state atrophied. Nero's fiddle is a warning about the dangers of a later stage in decline, when the arts have no longer any purpose at all, except as a distraction. At this stage of decadence they have no higher function than to divert us from reality. They have no part to play in steeling us to put out the fires of Rome, only to amuse us as the flames creep ever nearer.

The greatest lesson that we can learn from classical civilisation, that which animated the temper of the European renaissance, is that balance between the inspirational and the questioning, the Apollonian and Dionysian modes of art. From our study of these civilisations, and the roles played in them by all those things we

call the arts, we learn the importance of the critical tension which must be at the heart of the arts world (and must be at the heart too of any coherent policy). It is to our disadvantage that we currently seem to stand in need of re- learning that lesson. We have tended in many English-speaking countries to replace critics with experts, and to over-value novelty, wrongly presuming that the avant-garde is necessarily always challenging and Dionysian, and that our cultural heritage is predictably Apollonian, and safe. Our 'experts', our cultural bureaucrats, tend therefore to place too heavy an emphasis upon promoting what is simply new, expecting that its very novelty will make a newly produced book a challenging alternative to the safe Apollonian tranquility of Blake, Byron, D.H. Lawrence, Beckett and other comforting voices in our English heritage.

Instead of looking for such centrally important lessons that may be learned about the philosophies of arts promotion, we tend to ransack the past only for the comparatively minor techniques of financing and advertising art. That kind of search is bound to be fruitless unless it is linked to an examination of the role and nature of the arts themselves in the society we examine. That is because the arts predicate the way they are to be seen and heard. They contain (as it were) their own marketing systems, their nature suggests a managerial system that will finance and promote them most effectively. We cannot pluck systems - of state or private subsidy, for example - from the past or from different cultures, put them in place within our own society and expect 'the arts' to flow from them. We may sometimes learn much from the relationship between a legal and financial system and the art it seems to produce, but we can never just take a *system* (like the matching grant system, or the 'arm's length Art Council system') and transfer it from one cultural context to another.

Thus we cannot in any sense (unfortunately) transfer the system of public-spirited philanthropy which led the Athenian *choregi* - the businessmen chose to finance the ensemble work in the festival dramas - to be so willingly generous. In Athenian society there was no division between private and public philanthropy; sponsorship of this kind was a direct civic duty. It was not a duty done against the private will, but it was not a duty that could be avoided. It simply is not possible to transfer that system to a twentieth century

setting in which taxation, public duty and private generosity are separate and competing entities.

It could not be transferred for at least one other important reason. In measuring ourselves against fifth century B.C. Athens we have to recognise one crucial difference above all, which is that not only was funding the arts a civic duty, so was participation in them; attendance at the drama festivals was for full citizens *compulsory*, an integral part of Athenian citizenship. Thus the arts, and music and drama most particularly, merged not only with religion but with civic government. The debate within the drama was in a real sense a democratic political debate, in which it was a civic duty to join. In moments of great musical ecstacy, when Athenian audiences responded to the sublimity of their composers, it was in a sense a moment of national religious consciousness. The arts were thus both physically and metaphysically at the centre of the state's being; actors were both politicians and diplomatic messengers; musicians were priests and doctors. Athenaios the grammarian was not alone in claiming that illnesses could be cured by playing the pipes over the affected parts.

It is the homogeneity of Athens which makes any part of it impossible to transfer, for we cannot transfer the whole. In the festivals for example one did not have to argue over the ways in which trade supported the artistic contest, for art was seamlessly mixed with trade. One did not have to set 'art' and 'sport' as opposites because both were a part of the life of a rounded Athenian citizen. And much of that passed to Rome, although in a coarsened way. When Nero won the lyre-playing contest in the Greek Olympic games in A.D. 66, both in the faded Greek world and in the strife-torn Roman Empire the arts had slewed away from the centre of civic life and had become marginal, decorative, dispensible and exploitable. In a word, the arts had become, to anticipate a modern phrase, a business like any other. It is a significant fact that Nero, having won his musical honour, immediately embarked upon a commercial tour of Greece, cashing in on his victory by entering minor musical contests around the Aegean. When he returned to Rome he introduced a pattern of state-subsidised festivals, to take place every five years on what he saw as the Greek pattern, and, more regularly, promoted himself in a series of concerts to invited audiences. Then Rome burned, and indelibly etched upon history

the tragi-comic picture of the Emperor distracting himself with his fiddle - an eternal image of state support of the arts gone mad.

2: The Renaissance and Royalty

The Renaissance animated the British court, but it did not directly affect the majority of the British people. The profound social changes around the northern Mediterranean had no equivalent in Britain. In general the sixteenth century saw the establishment in Britain of a dominant court culture, which inevitably owed something to the renaissance ideals, but owed as much to the emergent Protestant Church. Increasingly, common pleasures and pastimes became constrained by royal decree, while favoured court entertainers were disproportionately supported. The gap between the 'high arts' of the court and popular art grew in size, and the differences became enshrined in law. The civil wars, and the eighteen years of the Commonwealth made rather less difference to art and artists than is sometimes said; Cromwell's tastes emphatically differed from his Royal opponent's, but he maintained a licensing system which continued to make a difference between those cultural activities permitted by government for its own élite, and common revelry. For many artists it was simply a matter of changing the name of their state supporter, while for many who relied upon the support of the common people things were not much harder than they had been in the time of Elizabeth or King James. And, although the Restoration of the Monarchy in 1660 has a hearty air of freedom restored, Charles' reign did not bring much easement to the lives of the majority of British writers, actors, painters and entertainers. The gap between the cocooned favourites of the Court and the artists variously trying to earn a living out in the towns and villages of post-war Britain grew, if anything, larger still.

The order which Henry VIII overthrew had the Catholic Church offering much support of music, and had many private landowners well established in philanthropic support of the arts, particularly of architects and painters. One prime result of the Reformation was

effectively to remove many of the alternatives to Court patronage, for the Church was now accountable to the Court, and landowners lost much of their freedom for independent action. The musicians now had to be re-employed at the Court or in the new Church; the taste of the rich became more obviously aligned with that of the King.

It was, however, Elizabeth I who developed the systems of licensing which gave the Court control over the presentation and performance of the arts. This was particularly so in the theatre. A series of royal edicts in the 1570s determined that no professional player could perform unless he were a member of a properly accredited company - a group of players, that is, who had acquired the patronage of a member of the landed aristocracy, and who carried with them their official document which, rather like a modern passport, requested that they be allowed to perform without let or hindrance. Sometimes such aristocratic patronage was further backed by royal licence, such as the one Elizabeth granted to Lord Leicester's men in 1574. Sometimes the patronage was itself directly royal, as was the accreditation which Shakespeare's company eventually enjoyed when they became The Queen's Men.

Favoured performing companies thus enjoyed both freedom of access to arts audiences and a degree of direct financial support. The Queen's Men, for example, were paid £50 from court funds for their winter performances before the Queen and her entourage. Indeed, although Elizabeth was forced into comparative frugality in her early years in power, her spending on court entertainments was still considerable.

We know this from the extant accounts of the expenditures of Elizabeth's Master of the Revels. This appointment, first made in 1545, was given in 1578 to Edmund Tilney, whose annual expenditures on Court entertainments soon exceeded two thousand pounds. It was in his time, in 1583, that the Queen's Men were formed into what was essentially the residential royal company of players. Alongside this generosity to the favoured, however, went an increasing tendency to control and curtail common pleasures. Granting of licences for annual fairs for many towns constrained what had been a comparatively open market for entertainers; there were now only certain days of the year when they could enter the

yards and market places which had been freely open to them. The Master of the Revels was further urged by Elizabeth to 'reform' all matter in public entertainments offensive to 'matters of religion or the governance of the estate of the common weale', and from 1581 he became the public censor of all plays and interludes. All new scripts had to be read and approved by him, for a fee of five shillings. (By the 1620s licensing a play cost two pounds, and the then holder of the post of Master of the Revels took a further slice of box office revenue.) Elizabeth also decreed that all printed books must be licensed by herself, or by six of her Privy Council - and that all pamphlets and ballads by a sub-committee of the Ecclesiastical Commissioners. Court 'support' went hand in hand with constraint through licensing. Public dances, musical entertainments and plays performed indoors now had to be licensed by the authorities of each town, and thus music-making was controlled in a new way. Favoured artists, however, were strongly supported; a licence dated 22nd January 1575 and signed by Elizabeth gives Tallis and Byrd a monopoly in the printing of all music in Britain for 21 years.

The effect of such licensing control was to make the divide between the high arts and common arts greater and to draw the arts world into London and the Court. That in turn meant that the arts audience was already becoming sharply divided. Although it was true that the Grammar Schools were spreading the spirit and learning of the Renaissance into the provincial towns of Britain, the successful scholars from that system, and particularly those who wished to participate in the high arts activity of the age, gravitated, like Shakespeare, to London. There was none of the general devolution that there was in Renaissance Italy; learning, art and style were firmly within Elizabeth's court and particularly in its London base. Four fifths of Britain's four million or so inhabitants were still rural, and without education. They did not form a part of Shakespeare's London audience which was comparatively small (excepting for the Public Holidays, he averaged less than a quarter capacity at the Globe, usually drawing two to three hundred clerks, city sophisticates and gentry at each performance). Moreover when Shakespeare or his contemporaries were forced to leave London and tour, they did not have to travel far before they found an audience that could not understand, still less enjoy, their sophisticated dramas. There is for example a record

of the local bouncers having to move in to quell an unruly audience at a performance in Norwich - which one might have assumed to be sophisticated enough to understand the contemporary drama.

Censorship did not then suddenly arrive with Cromwell and the Commonwealth; rather it changed its emphases. London society and its Court were naturally enough targets of the Puritans, but in spite of the order to close playhouses, and in spite of the attacks upon them by the army, it seems certain that a number of performances were given during the Commonwealth, at the Red Bull, Salisbury Court and the Fortune. And, in spite of the dismissal of the royal musicians, and the order to destroy some of the organs that had been used for irreligious music, London's musical life seemed to go on, and in some ways even to prosper. Captain Cooke, an avowed Royalist, continued for example both to teach and to play in the capital. In the *Musical Banquet*, published by Playford in 1651 - one of an impressive string of musical publications produced during Cromwell's regime - there are eighteen teachers listed 'for voice or viol' and nine teachers of the 'organ or Virginall' in London.

The frequently repeated story that Cromwell destroyed British artistic life is quite untrue. He was a lover of music, and maintained a retinue of instrumentalists and choristers. The wedding of his daughter in 1657 was in some ways reminiscent of the old court revels; music from fifty trumpets and forty-eight violins accompanied the mixed dancing, which went on until five in the morning.

Nor was he the humourless scourge he has sometimes been depicted. He maintained four jesters, or buffoons, whose sole purpose was to amuse him. And in the country, the British sense of humour was by no means extinguished, as an ironic prayer of the time might indicate:

Thou shalt have no other Gods but the LORDS and COMMONS assembled at Westminster. Thou shalt not make any addresses to the King, nor yield obedience to any of his commands; neither shall thou wear any image of Him or his posterity; thou shalt not bow down unto him, nor worship him, for Wee are jealous Gods. Thou shalt get all thou canst; part from nothing; doe no right, take no wrong, neither pay any Debts. Thou shalt enjoy thy Neighbours House, his Wife, his Servant, his Maid, his Oxe and his Asse, or any thing that

belongs unto him, Provided that hee first be voted (by Us) to be a wicked or ungodly person.

That was published, as an attack on the Long Parliament, in 1647. Indeed, in spite of the distressed state of some writers - Richard Lovelace, the poet, was impoverished by the Commonwealth, and died young - there was much of value published. During the Commonwealth works appeared by, amongst others, Herrick, Cleveland, Marvell, Dryden, Browne and Milton.

For the majority of the population, the available entertainments would have changed very little. And even in London, great writers, painters, architects and even arts administrators showed a remarkable resilience. When the Royal Office of Works was closed in 1643, for example, it might have been thought that Inigo Jones, whose work had been all in and for the Court, would have ceased to work. Yet when Parliament created its own office of public works, Inigo Jones was duly called upon to advise on several projects. In 1654, Gibbons went to hear another avowed Royalist, Gibbons, give a recital on the organ at Magdalen College. Another supporter of the King, Sir William Davenant, emerged from more than two years in the Tower, in 1656, and immediately set about planning - with Cromwell's consent - London's first opera season.

Court and Commonwealth had two important attitudes in common. Each believed that although common pleasures should be rigorously controlled, a greater degree of license could be permitted in their own, more sophisticated circles; you could mock the Court, or indeed Cromwell and his retinue, to their faces, but not to do so with impunity at a country theatre. Both the Court and Parliament forbade any kind of debate about what was and what was not to be considered treacherous or profane. *Officials* decoded the arts and decided whether or not offences had been committed; there was no inclination to appeal to the common will, nor to debate such matters in the way they had been debated in classical civilisations. The court, its privy councillors, and parliament and its officials drew to themselves all the powers of censor, licenser and critic. No separate arts policies were created; the system of control in the arts was predicated by the general political philosophies of those in power.

With the Restoration of the Monarchy in 1660, there was no revocation of much of this. If anything, Charles II made the divide between the high arts and their privileged entourage, and the popular arts, wider still. Indeed few of the former freedoms were restored. In the times of the previous Court for example there had been some dozen and more theatres and inn yards where the drama could be seen. After 1660 the restored King licensed only two theatres in London, and none in the provinces. These theatres - Drury Lane and Lincoln's Inn Fields - were run by Killigrew and the irrepressible William Davenant, there 'to act plays in such house by him erected, and exercise musick, musical presentments, scenes, dancing or any other like'. The dramas produced in these new 'tennis court' theatres, now fully roofed, were played by actors and actresses - the first time women had acted in British companies. Some of the Restoration drama played in these London houses was fine stuff, but it is hardly possible to overlook the fact that for a long time it was a civil crime to act the national drama on any other but a royal stage.

Although royal permission was subsequently given to open 'Theatre Royals' in several major provincial towns - Norwich and Bath in 1768, Liverpool 1771, Manchester 1775, Bristol 1778 and Newcastle in 1778 - the fact remains that the great majority of the British people were forbidden to enjoy the national drama in their own towns and villages, unless it suffered ridiculous mutilation and was presented with much music and dancing, for nearly two hundred years - until the 1660 Patent Theatres Act was finally repealed and replaced in 1843. That astonishing period of government repression should never be forgotten when we lament the fact that so comparatively few people go to the 'serious' modern theatre. It was official legislation that forced them to relinquish the habit. In Shakespeare's own time some thirteen to fourteen per cent of Londoners went to the theatre each week. After the Restoration the figure never again rose above five per cent, and in our own century the figure has gradually shrunk, until at the present time rather less than one per cent of the population of London attend the theatre at all regularly.

Publication however did not suffer the increased constraints of theatre. Although Parliament passed in 1663 a new licensing act, aimed at the control of seditious or heretical works, it was in disuse

and finally repealed by 1696, after which the British were in theory permitted to print and publish whatever they chose. Constraints remained, however, though of a more oblique kind. Licensing acts had reduced the number of licensed printers in the kingdom to twenty; it was therefore not always easy to have work actually printed. Moreover the various campaigners for censorship, though operating without legal backing, were far from silent, and it was hard to forget that only a short time has elapsed since Judge Jeffreys, amongst others, had been passing savage sentences upon the writers and publishers of dissenting literature.

Painters and musicians had none of the problems of the theatre or of publishing; portrait painters, architects, composers, music teachers and dancing masters all lived well. There were desertions from authorship and the drama, Congreve and Vanbrugh being the most obvious examples of playwrights who found more satisfying uses of their creative energies in other fields. The realms of music and of art swelled meanwhile, and by the end of the century the signs of an arts market supported by an increasingly cultured middle class and no longer dependant upon the patronage of state or the church were already evident. In 1688 Gregory King's survey of the occupations of the British suggested that there were already 15,000 families in the land whose chief occupation and income was from practising within the liberal arts and sciences. The average income for each of these families King estimates as being £60. If his figures are at all reliable we may therefore assume that the 'arts markets' of the late seventeenth century already had a turnover of almost a million pounds each year, a figure which outweighs the remaining patronage of the Court and of the noble families. Over the following century those markets grew prodigiously, and, for a period, the 'high' and the 'popular' arts were as one.

3: The Eighteenth Century and the Free Market

The growing middle class in the eighteenth century, living in times of comparative peace and affluence, created the first substantial open market place in Britain for all the arts. Although the state offered virtually no kind of patronage - with the exception of such occasional forays into the arts market as the partial purchase of Sir Hans Sloane's collection of paintings in 1753 - its restrictive hand upon arts management was less weighty than it became in the nineteenth and twentieth centuries. Artists both travelled and traded much more freely than they had done in the sixteenth and seventeenth centuries, and writers, painters, composers, architects and teachers of the arts all flourished. Most particularly it was a happy time for writers. The readership for poetry, for pamphlets and for the new novels of the times grew prodigiously. At the turn of the century there were just over 300 titles being published annually, but by 1850 there were 2,600. Readerships of thirty to forty thousand for successful novels or best-selling poems became commonplace, and writers lived well from their sales. Whereas Milton had fifty years before made only £10 from the whole of the first edition of *Paradise Lost*, Pope made £4,000 from the *Iliad*,

Johnson's proclamation of the common sense is the prevailing image of the eighteenth century. It was not the Court, nor the Church, nor indeed any narrow group of state or private patrons that determined excellence in art, it was rather determined by a public judgement. In the critical journals of the eighteenth century there was a continuous publicly-waged dialectic about art and artists which came nearer to genuine *participation* on a large scale than subsequent critical processes. The *Vox Populi* was for a period triumphant, and criticism was an open and public matter — very different from the fate of artists being determined by the Court, in

the private recesses of the Lord Protector's entourage, or in the secret meetings of an arts council. Even in so comparatively subdued an art form as the theatre — Walpole had greatly tightened the screw of state censorship in 1727, and the licensing prohibitions of the 1660 Patent Theatres Act were still strongly in force - the claim of the common will was recognised. As Garrick said:

> The drama's laws the drama's patrons give,
> And we that live to please, must please to live.

Although some artists still sought and found private patronage, many exsisted solely by virtue of selling in the open market, finding it with Joseph Haydn, who had fled the stifling patronage of middle Europe, a 'sweet degree of liberty'.

The management of the various arts became a serious profession. The publishers, booksellers, print shop managers, concert hall owners, theatre managers and patentees, coffee house proprietors, art exporters, and the new breed of arts marketers caricatured so splendidly in Sheridan's The Critic, totalled more than five thousand. No town of a thousand inhabitants, by the middle of the century, lacked a theatre, print shop, bookshop and most had some form of circulating library. Aldermen joined with rich industrialists in many towns to sponsor the building of Assembly Halls, Public Theatres, and Concert Rooms. The habit of public subscription to build venues and establish public facilities was widespread, from the subscription by the rich syndicate that built the Italian Opera House in 1705, to the subscription from very much poorer folk which built the Assembly Rooms and Concert Rooms up and down the land. The newspapers of the eighteenth century give us also a picture of the swelling ranks of successful artists in each town and village who were able to earn their livings on a scale without precedent in British history; portrait painters, garden designers, dancing masters, music and art teachers advertised their wares in the newspapers of the market towns as well as in the publications of the increasingly fashionable spa towns. The price ranges were very great. It would cost you as little as a shilling to hire a fiddler for your daughter's birthday party in a country town, but cost you £100 to hire a good portrait painter in

London. Artists now found themselves rich. In Bath, the musician Herschel made £500 a year. In London Hogarth made £12,000 from *The Harlot's Progress* alone. When Reynolds died he left more than £100,000. Meanwhile up and down the country the travelling showmen grew in number and although few prospered, many more made a living from their sideshows, puppet booths, conjuring and musical entertainments. By the middle of the century there were at least twenty practising artists to each administrator, and thus more than a hundred thousand people earning their living from 'the arts'.

A growing middle class market meant both that the financial support of art had shifted its base, and that the purposes of art had widened and changed also. The purpose of art was no longer to flatter the values of an élite, nor to provide amusement and distraction for the priviliged, but to be a part of a more general process, of refining and civilising a significant part of the population. It is now possible to perceive 'culture' as being a process, and, by a definition which has in our own time once more become distorted, the arts were then perceived as being educational. The many books published in the eighteenth century on manners and refinement repeat again and again concern of the age with just those things which had concerned the Athenians - the relationship between the state's practices and the freedom it gave to live life well, the balance of art as inspiration and art as criticism, and the concern for the dialectic of arts debate. To take one example from many, a publication of 1763 had Pope's epithet upon its title page:

'Tis Education forms the tender Mind,
Just as the Twig is bent, the Tree's inclined.

The book, a series of letters, is — again, typically — addressed to a girl desirous of gaining an education in the arts. Good breeding, sophistication, cultivation, politeness, aesthetic skills, culture and good manners are here all merged into one; an education in the arts is an education if life *and* manners. *The Polite Lady, or a Course of Female Education* abounds in examples of the desirable coalition of art, manners and life:

I had the great pleasure of hearing of your welfare, and of the great improvement you make in dancing. This is one of the most genteel and polite accomplishments which a young lady can possess. It will give a natural, easy and graceful air to all the motions of your body, and enable you to behave in company with a modest assurance and address.

'To be able to read with propriety, is certainly a very genteel accomplishment and not so easy to be acquired as most people imagine; and perhaps there is not one woman in five hundred that is possessed of it. There are so many vicious ways of reading, which young people are apt to run in to, that it is difficult to avoid them all, and when once a bad habit is contracted, it is almost impossible to correct it. There is your Aunt F_____, who reads with such a canting tone as grates the ears of the whole company; she has frequently almost flung me to sleep though reading one of the most diverting books in the world. Your cousin P_____, you know, reads with such hurry and rapidity, and such neglect of the proper stops and pauses, that the most attentive hearer cannot understand one sentence she pronounces; whilst Mrs D_____ reads in such a slow and slovenly manner, and draws out the words to such an immoderate length, that no body has the patience to follow her. Mrs N_____ reads with such a loud and shrill voice as stuns the ears of the whole audience; it might do very well for a public assembly but it is altogether unfit for a tea table; whereas Miss L_____'s accent is so faint that you must apply your ear almost to her mouth, before you understand the subject. All these are vicious ways of reading, which you ought carefully to avoid.

As most young ladies are taught to play on the harpsichord, the spinnet and guitar, I expect you will learn to perform on all these instruments, especially on the first, which has a greater variety of notes and a larger compass than either of the other two. But still, I would have you to apply your chief attention to vocal music, because, in its perfection, it is of a far more excellent nature than that which is merely instrumental.

'No young lady deserves an honourable character without a competent knowledge of the art of drawing. Were it only to be considered as an innocent amusement, yet even in this light, would it merit your attention; for innocent amusements are of more importance to our happiness, and perhaps to our virtue likewise, than many people imagine. The most active and busy stations of life have still some intervals of rest, some hours of leisure; the body as well as the mind requires it; and, if these are not employed in innocent amusements, they will either lie heavy on our hands, and, instead of raising, depress our spirits; or, what is worse, tempt us to *kill the time*, as it is called, by such amusements as far from being innocent.

What is most noticeable about this and so much else in the eighteenth century is that the arts are by and large a private and personal activity, to be pursued largely within your own home. Musical instruments, prints and books appeared not only in the houses of the comparatively affluent, but in many ordinary homes in provincial Britain. Bookshops, print shops and libraries were, together with the craftsmen, selling musical instruments, brushes, inks and all the materials for domestic creativity, evidence that the arts had entered the homes of many Britons, and that the daughters (if not all of the sons) would be expected to be versed in drawing, music and reading. The growth in the numbers of artists earning a commercial living from their work was duplicated many times over in the growth of creative activity within the home. 'The arts' then referred to the processes by which many Britons, perhaps a majority, lived, referred to private as well as public activities, referred to the act of creation by ordinary folk as well as to the commercial market for the work of professionals. 'The Classical Age' of the eighteenth century thus reproduced some aspects of the classical civilisations; private cultivation was not wholly separate from public responsibility, and all creative activities were subjected to astringent analysis and debate.

For the common sense of Dr Johnson's century ensured that the arts were not spread out through the population as a kind of bland service, but that *critical* participation within the culture spread along with the means of creative participation. The *Spectator* and the *Edinburgh Review* were of an open and inclusive character; in the inns and coffee houses the discussion of the latest play, of the newest novel and of the scientific discoveries of the age were serious; once more debate about the arts became a civic debate. And because art was not *provided* in response to *needs* perceived by bureaucrats, but was a part of ordinary living and hence nurtured and evaluated by the straightforward wants of people, the new and thriving world of commercial art did not mean any lowering of standards to satisfy some supposed low level of popular taste. Tha Adam Brothers, Chippendale and Sheraton did not feel that they were producing furniture for a new and larger public and that they therefore must make it more crudely. Nor did 'the common taste' impel Dr Arne to simplify the scoring of his

music, nor Pope to write more blandly. The belief was that provided the general debate was kept open and vigorous, the market place would sustain the art which mattered. Dr Johnson, who made £1,575 from his dictionary, sternly opined that no-one but a fool ever wrote anything for money.

In the visual arts, thanks largely to the pressures brought by Hogarth, a copyright law had been established for artists which gave painters and printmakers a new form of ownership of their works. Nothing like that existed for musicians and writers, and so they usually sold their work outright or came to their own agreement with publishers. But money was in that century a reasonable yardstick; by and large, the best got paid the most, and did best in the open market. Artists became well-to-do and (with the exception of the theatre which remained repressed by state law) their professions became respectable. In the reign of George III court patronage re-emerged with a different emphasis; it no longer existed to subsidise the aspiring artist, rather to reward the ones who had long proved themselves in the market place. In 1768 the Royal Academy of Arts was founded, largely as a meeting ground for the well-established and influential, and court patronage was extended to successful writers too. In 1763, when he first met Boswell, even the doughty Dr Johnson had accepted a pension from George III.

Parliament, however, made only the most cursory attempts at patronage. Even the monies voted in 1753 to purchase Sloane's paintings proved insufficient and had to be supplemented by a public lottery. On the other hand some of the constraints upon arts markets were removed; the prohibition upon the numbers of publishers permitted in the realm had for example been lifted and in the middle years of the century their numbers grew, particularly in London and in Edinburgh. The main government intervention in the eighteenth century was an indirect one, and lay in the provision of buildings and meeting places in which the arts could be practised and enjoyed. Civic authorities began to plan their towns and cities - a movement which may be said to begin with the development of the Covent Garden plazza in 1630, but which gathered pace in the early eighteenth century. Grosvenor Square in London was designed around 1730, while in Bath John Wood built Queen Square and the Circus. His son built the Crescent. In York William

Kent built the Burlington's Assembly Room. In Oxford Gibbs built the cylindrical and domed Radcliffe Camera. Smaller towns copied the capital, the university towns and the fashionable spas, and had their own classical meeting rooms, libraries and civic halls. Thus an eighteenth century British town had its commercial theatre, its commercial print and book shops and usually its own civic buildings, provided by local subscription and from civic funds, in which meetings, concerts, readings and instructional lectures would be held. The local newspapers would be a mass of advertisements for these public events and for the artists who would come to your home to paint or draw, or to give you and your children instruction in such cultivated delights.

Behind the pleasing and harmonious sophistication of the elegant towns, however, lay two disquieting facts. First, the poor rural population was becoming separated out from the new urban sophistication. In the new novels, of Richardson and Fielding in particular, the ambitious young of the countryside generally turn their backs upon the rural life and head for the fashionable pleasures of the metropolis, and in them, and in the plays of the century's best-known dramatist Goldsmith, there is a continuous gentle ribbing of the countrydweller. Like Mr Hardcastle in *She Stoops to Conquer* the countryman loves old things, and is honest and decent, but he is slow and mightily unsophisticated. For him there are the old pleasures of the chase and the country inn, the family games and the village traditions. His wife may (like Mrs Hardcastle) hanker after the fashions and gaieties of London, but he knows he would be ludicrously out of place there, amongst the coffee house chatter and the society balls and the opera-going and the smart exhibitions. One did not have to venture very far from London, or Bath, or York before one was in a different Britain, and the experience was often disturbing. When London society travelled to the (then) unknown territory of Stratford on Avon for Garrick's Shakespeare Festival there in 1769, they entered what was to them a foreign land; dirty houses, ill-kept inns, dreadful dirt-track roads, animals - a world that the urban sophisticates could hardly believe had nurtured the poet, and certainly a world miles removed from all they were now understanding by the term 'the arts'.

Second, there were already some voices raised in alarm at the spectre of the arts continuing to spread, so that artists, now respectably perched at the side of the ruling élite, could once more be demoted in popular estimation. Goldsmith feared that writing might become a trade, rather than a calling. As soon as such a distinction is made, and such a fear expressed, art is losing its position at the centre of life and is arguing for its survival because of its importance to the influential and its promulgation of what we earlier called Apollonian values. The eighteenth century order is better remembered by Pope's wryly detached couplets:

> As yet a child, nor yet a fool to fame,
> I lisp'd in numbers, for the numbers came.
> I left no calling for this idle trade,
> No duty broke, no father disobey'd.
> The muse but served to ease some friend, not wife,
> To help me thro' this long disease, my life.

Goldsmith's fears were prophetic. Barely a decade after his death, with the publication of the last three volumes of Gibbon's *Decline and Fall of the Roman Empire*, the spread of artistic expression through ever increasing commercial markets had reached its zenith. In its broadest sense the market in Britain for good writing, good music and good art, together with the scale of participation in music, dancing, painting and literature was larger than it had ever been before or has been since. Arguably too the freedom of artists to say what they wished, however much constrained by the self-imposed constraints of the age of reason, was as its height. Government control was less than it had been in the previous century. It was also much less than it proved to be in the succeeding century, for the authorities perceived in the accelerating drift to the new industrial towns and in the ideas being fed to people, a new danger, the risk of mob action. A fear of large new gatherings of people, fed by the Dionysian notions of unconforming and revolutionary artists, was distilled into a general fear of the mob. New constraints on the rights of assembly, on the freedom to publish and on the rights of free speech, on general education and on the role of the orator, teacher and critic began to appear. Then in 1789, as Blake published his *Songs of Innocence*, the Paris mob stormed the Bastille.

4: The New Industrialisation

The industrial revolution took millions from their rural lives and gave them a kind of work in new industrial towns and cities. That work gave nineteenth century Britons a new concept of leisure, because in the new factories they worked fixed shifts and, equally compulsorily, had a few hours in their new habitations which they were forced to devote to their new 'leisure'. Previously their time had been much less measured; if the season and weather were right they would have worked from dawn till dusk, but in other seasons they would have gone walking, or hunting, would have sung catches or played a game of skittles, without any sense that they were doing it 'in work time'. The revolution also gave them a (pitifully small) amount of money to spend as they chose, where formerly their wages had largely been in kind. But it took them into an environment in which they could no longer do those things which for centuries had given them pleasure; the arts they had practised in rural Britain could not be practised in the new industrial towns where there was no space, no greenery, and no common ground to kick a ball in, nowhere to shoot, ride, snare fowl, dance or fish. The village games could no longer be played, the catches and glees no longer sung, for people lived in mean dark houses too close to each other for any display of high spirits to be other than offensive. The old pastimes, the bucolic arts of old Britain, were now relegated to the obscurity of the distant countryside, and the new civic leaders of industrialised and urban Britain did not give them a further thought.

The industrial towns grew at an alarming rate. Places such as Middlesborough, a modest village at the turn of the nineteenth century, swelled into great functional towns in two or three decades. London's population at the beginning of the nineteenth century was 959,000, and by the end of the century 4,546,752; Greater London (an entity which did not exist in 1800) had a

31

population by 1900 of 6,528,434. The swelling cities - Manchester, Leeds, Sheffield, Liverpool, Bristol, Bradford, Newcastle - posed immediate questions of control and public order. And they posed immediate questions of what became known, almost at once, as 'the *problem* of leisure'. People could no longer enjoy themselves in ways they had traditionally done. The new mean back-to-back homes of the smoky industrial districts did not permit them much possibility of recreation at home, so where was their leisure to be spent? The new authorities, with their growing powers and authority, and their growing sense of civic responsibility, found themselves central figures in a war for leisure time. On the one hand those who wished to see the new leisure as a potential for *improvement*, the factions in national and local government who, led by the powerful figure of Prince Albert, saw the need as being one for civic museums, reading rooms, instructional galleries, and all the means of self-education; and those who saw the new leisure as a time in which work could receive its *reward*, the entertainers, artists and performers who wished to amuse and distract the population and wanted less to instruct and improve than to bring pleasure and immediate satisfaction.

The war was fought on many different battlefields. It was fought within the realms of licensing. Civic authorities in the new cities put up their own libraries, museums and concert rooms, but, in a manner which recalled the stricter licensing systems of the sixteenth and seventeenth centuries, began to take to themselves all manner of new licensing restrictions to limit popular fairs and carnivals and to license popular entertainments. A ripple of national legislation following upon the Public Entertainments Act 1875 and the Metropolis Management and Building Acts Amendment Act 1878 effectively brought all kinds of performance under government licensing control; no longer could the travelling showman erect a booth in a farmer's field, or a village build its own village hall just as it wished. Every concert, every play, every public exhibition now had to take place in a venue licensed for the purpose by national or local government; theatres and concert halls were now anually inspected to check that an ever-increasing list of safety requirements was being fully met, and the characters of the managers were now taken into account before licenses were issued.

The risk, the raffishness and the freedom were all together being extinguished from arts management.

The Fairs Act 1871 granted the Secretary of State powers to abolish altogether certain of the old fairs which had operated in Britain's towns and cities since Elizabeth's day. From 1874 showmen were additionally banned from selling liquor in those fairs which remained, without special permission. And licensing restrictions upon the sale of alcohol (popularly and wrongly supposed to stem from the First World War) became tighter shortly afterwards. The Public House Closing Act 1864 specified weekday closing hours for London pubs (their Sunday closing hours had already been curtailed) and in 1872 there was similar legislation for public house hours outside London.

Perhaps the most curious paradox which resulted from the new legislation was in the scale of provision. At the beginning of the century arts managers sought to cater for huge audiences. The pleasure gardens of London could take more than forty thousand people a night. The average capacity of London's leading theatres immediately after the Theatres Act 1843 (which supposedly liberated the drama, and gave *any* licensed theatre the right to present the legitimate drama) was well over 3,000. The famous circus building, Astley's, accommodated nearly 5,000 people. Richardson's touring theatre booth, which reared like the Parthenon in many of the larger fairs, held more than 2,000. In the pleasure gardens, large public houses, provincial theatres and assembly halls entertainment, art, politics and instruction were all mixed together still; in a London pleasure garden such as the Eagle you could dance, sing, eat and drink, watch magic, enjoy pantomime, see a play, watch puppetry, listen to a preacher or enjoy an exhibition of paintings. There were public houses which did duty as schools, as concert halls, as political meeting houses and as playhouses, in addition to providing rest, drink and food. Yet by the end of the century 'art' had almost completely separated itself out from religion, politics and common entertainment. And, although advances in building technology meant that had they wished managers could have built their venues much, much larger, in practice they chose to build them smaller. By the end of the century trim public parks with a few benches had replaced the rough old populist pleasure gardens; the average size of London's

fashionable theatres had shrunk dramatically, and where music or entertainment went on in pubs, it was separately licensed and usually contained within a small back room. Although entertainments managers still catered for the large scale - in places such as Blackpool a new popular business was growing in providing entertainment for holidaymakers, pleasure for the masses - the arts were now offered to a well-heeled minority audience in small and distinct venues, art for the educated, improvement for the privileged,

That deliberate diminution in the scale of provision was matched by a radical alteration in language. 'Art' now referred to what could only be, by definition, a minority activity. It was held to be excellent when it was presented in conditions of refinement, attended to by persons of discrimination and taste, paid for by people of rank. The popular days at exhibitions were now held to be vulgar; pictures should be seen away from the common crowd, and in the company of cultivated aesthetes who could appreciate them properly. The leading London theatre managers likewise rested their case for their work being recognised as high art less on the quality of what happened on stage than on the quality and breeding of the audiences they attracted. The Bancrofts, like Hare, Kendall and others, endlessly stressed how the rich and famous had been drawn to their theatres; Irving spent a fortune bribing the powerful to come to the Lyceum, where he entertained ceaselessly in his special backstage dining room, and endlessly solicited their support. In the fashionable theatres full evening dress was *de rigeur* in all the pricier parts of the house. The economic foundations of the arts shifted accordingly; in the new small venues income was dependant upon a few people paying quite a lot of money, while in the vulgar old days they had relied upon a lot of people each paying comparatively little. At the end of the century more than 75% of the nightly income for the populist Britannia Theatre in Hoxton came from the pit and gallery, while in the much smaller, much more fashionable theatre that Beerbohm Tree had re-built, Her Majesty's, more than 75% of its nightly income came from the stalls and the dress circle. Indeed the wish of the new minority theatre managers, who saw themselves as *art*, to exclude the common man could hardly be made clearer by their actions. To book for Tree's stalls or dress circle in advance at one of the more

fashionable libraries you would have had to wear proper morning clothes. To attend the performance you would have had to wear evening dress. Ordinary folk had neither, so even if they had the ten shillings and sixpence for a ticket they were effectively debarred. Nor were they particularly welcome in the other, less fashionable, parts of the theatre. It was only the vigorous intervention of George Bernard Shaw that prevented Tree from actually closing the theatre gallery altogether, as being too much of a nuisance to run.

In education could be discerned another battleground in the war between the improvers and the entertainers. In school curricula there was no mention of the old bucolic arts, nor of the popular urban pastimes. The old folk songs were not sung, nor were the songs of the music hall; instead children learned improving hymns or chanted specially composed pieces which were thought to be pure and beneficial. Newspaper cartoons and the vivid new painters were not to be seen in schools; instead classroom walls were decorated with occasional prints of stuffy old 'classics', rather depressing religious paintings as a rule, and the pupils learned 'drawing'; painfully wrought compositions which had the right perspective and which later could be 'shaded in'. There was none of the vigorous acting there had been in Elizabethan schools. Dancing was replaced by a dull and mechanical Physical Education. Large parts of the English Literature were missing from school libraries, as was the entirety of popular publication; instead children read bland and bloodless primers, text books and heavily expurgated 'children's classics'. The new state education system, particularly as it grew after the Education Act 1870, did little to acquaint its charges with their own cultural history or indeed with their contemporary popular culture. It prepared the mind to receive a faint impression that there was something pure and good out there called 'art', a state to which only a privileged few would be called, but also to receive a strong impression that there was something vulgar, dirty, second rate and cheap about all that common people enjoyed, and all that they did. 'Art' was something which belonged to your elders and betters, something for the well-educated and the well-to-do. You could 'improve' yourself by learning a little about it, by adopting some of the attitudes of the fully-fledged aesthete, but most people could not, in the new

definition of the term, be fully inward with the 'arts' as so many people had been in the previous century.

Particularly, you could not really be in the 'arts' unless you were urban in thought and deed, and you would usually — with rare exceptions such as Tennyson or Morris — find it difficult unless you were a London dweller. Art was now a judgemental term and it was a metropolitan élite which made the judgements. The new industrial cities often tried to emulate the capital, but everybody knew that in Birmingham, in Liverpool, in Leeds or in Manchester the arts, however worthily presented, were second rate. *Provincial* became a mildly pejorative term. Another disapproving term was *mass*. This was a new word for mob, a notion which already aroused some disquiet in the establishment mind, but *mass art* now became a contradiction in terms. The very act of replication (of a picture, of a musical composition, or of a play) removed it from the pedestal; large unrefined audiences somehow contaminated art by implication. So, although there is every evidence that in the new industrial towns there still was potential for a *mass provincial audience* for the arts, the new meaning of the word meant that such a thing could neither be encouraged nor envisaged.

The new industrialisation thus inflicted three grievous blows upon the majority of the British population - blows similar to those which colonialism was to bring countries of the third world in the twentieth century. First it effectively removed them from their traditional bucolic pleasures, the culture of the 'old England'. Second it constrained all forms of urban entertainment which, however much in demand, seemed to the new civic authorities to be examples of Satan finding 'things for idle hands to do' in their new, enforced, leisure time. Third, it replaced such direct pleasures with a deliberately scanty 'provision' of art, which, it was taught, was a highly desirable and wholly excellent thing, but which was encircled by so many educational, social and financial walls, each of which was hard to scale, that it was, for so many people, a state of grace which they had no realistic hope of attaining.

Some circles of government were beginning to talk of 'arts provision' by the end of the century. Yet by then any notion of a general kind of welfare provision had given way to a feeling that the wants of ordinary people should be reinterpreted as the needs

of the cultured élite, Prince Albert's ambitions to build a dozen and more national museums throughout the land had been boiled down to one, the Victoria and Albert, built, inevitably, in a fashionable part of London. Discussion about general provision of theatre had boiled down to wearisome polemics about one National Theatre, which would of course be in London, the only problem being how best to 'fund' it. The rest of the country's theatres would continue to subsist on plays on their way in to the Mecca of the West End, or on their way out of it. Although some of the resort authorities funded orchestras - Bournemouth and Eastbourne, for example - London had begun to accumulate orchestras, and was already moving towards the familiar situation whereby everybody acknowledges that there are too many orchestras working in the capital but none of them will ever agree to leave it. The interests of the metropolitan arts coterie are now paramount. 'The arts' are by and large what they judge to be desirable. They too have a near-monopoly of determining 'needs', and the 'needs' of the nation are presumed to be for what they judge to be art. Already the whole complexity of issues within the whole realm of arts creation and arts management tends to boil down to the simple question of how the metropolitan culture houses are to be funded.

In all of this the most important loss can easily be overlooked. That is the loss of common sense. 'The arts' are now wholly separate from citizenship, or from the religious lives of most people, and indeed from the education service. They are a minority pastime, moving ever further from the common people, a separate construct, a separate bureaucracy or a separate industry. They no longer play any part in the public forums of debate; indeed the new popular press hardly ever mentions them. The new Theatrical Managers' Association advertises regularly in the minority papers that reach the right sort of home, but you could read *The Police Gazette* all your life and never know that England had a theatre, still less that it had once had a popular one.

5: The Media and the Mob

Another event, considered at the time to be merely a passing sensation, occured as Beerbohm Tree was spending £70,000 on renovating and redesigning Her Majesty's theatre. In 1896 at the Regent Street Polytechnic a moving film was shown in public for the first time. Thr age of the 'mass media' can be said to date from that showing as plausibly as from any other date.

The twentieth century media face us with two startling facts in considering the nature of arts policy-making. First is the uncomfortable truth that first film, then radio, then television and the whole recording industry have been seen not as allies but as enemies of the arts. Second, governments have in general adopted radically different policies towards the 'high' arts and towards the 'mass' arts of film, radio and television.

The antagonism between the arts and the media is founded upon two long-held fears. 'Mass' is, as we have said, a new word for 'mob', and the ruling powers had feared the powers of the mob for centuries; the mass media spelled out albeit indistinctly a threat to the security of the metropolitan establishment. Second, the media seem to be a trade, a consumerist activity in which the excellence of what it does and says seems inevitably besmirched by the general coarseness of its audience. This antagonism leads governments to take quite different views of the two entities. 'The arts' are held to be in need of subsidy and support, to make them more widely accessible. The media, already widely accessible, are seen in general to be in need of control and, far from being in need of subsidy, usually a prime target for various forms of taxation. Governments which use their indigenous artists as exportable currency will often go to great lengths to prevent the importing of media art; South Africa for example spent some decades both in exporting their artists and trying to get overseas artists to work in their country, but had no domestic television service.

Returning to the fledgling film industry, only two years after the erection of London's first purpose built cinema in 1909, the Society of West End Managers passed a resolution:

> That in the opinion of this Society the giving of facilities to the Managers of Picture Palace Theatres enabling them to take cinematograph records, or films, and so to reproduce theatrical performances, is very prejudicial to the general interests of the theatrical profession and is accordingly greatly to be deprecated.

The theatre managers' alarm was understandable. The film business which had begun less than twenty years previously at the Polytechnic was now in Britain a rapidly growing concern, with 300 separate companies and nearly £3,500,000 capital. The following year the *London Evening News* pointed out that there were more than 50 cinemas in central London and a total in the capital as a whole of more than 500. They had, in little more than a decade, outstripped theatres in size and number and of course they (and the fast-growing professional sports businesses) seemed at once to capture the popular audience that the theatre, in particular among the arts, had cold-shouldered.

As the cinema grew in popularity so did the vehemence of its critics in denying that it had anything to do with art. In 1922 Young claimed that 'under cover of darkness, evil communications readily pass and bad habits are taught. Moving picture theatres are favourite places for the teaching of homosexual practices.' Ervine in 1934 wrote a book entitled *The Alleged Art of the Cinema* which was a vitriolic damnation of film as a medium and which concluded that it was *not* an art. The actor Fred Kerr in his *Recollections of a Defective Memory* (1930) does not deny the cinema's entertainment value 'if only we could be spared the ravings of the press about its artistry'. In spite of this, the public made it abundantly clear that it wanted films, whatever its needs were adjudged to be. In the year following the First World War each Briton was making on average some eight visits to the cinema; by 1930 this had risen to nearly twenty, and in the first full year of peace following the Second World War, each adult went, on average, once a week. This was however still thought a matter for alarm by some government circles, and by moralistic writers such as Harding, who had asserted in 1942:

We are defaming our morals, corrupting our youth, inflaming our young people, exciting passion, debauching our children, making prostitutes and criminals through cinema-going.

This echoes the writer Rice who had described *Snow White and the Seven Dwarfs* in 1938 as a bad film because 'children will get accustomed to thinking the movie theatre is a proper place to be entertained'.

Governments everywhere were faced with the same problem as Britain, as the film industry grew. None of the aggregated legislation which controlled the other arts readily applied to a totally new industry. Everything — copyrights, licensing cinemas, taxing entrance monies, censorship, safety requirements — had to be thought out afresh. In practice this never happened in any coherent way in Britain. Legislation arrived piecemeal. The industry erected its own system of self-censorship, the British Board of Film Censors, which government after protracted wrangling accepted - although local authorities which license cinemas may still overrule their findings. In like fashion the industry imposed its own copyright systems. Tax in Britain was an Entertainments Tax, started in 1916 to aid the income for the war effort but continued for half a century, and which was levied on theatres, concert halls and cinemas alike. In spite of occasional reports (most notably the five reports of the Interim Action Committee on the Film Industry, which had been set up in 1976 by the then Prime MInister, Harold Wilson, to advise government on film policy), Britain has never had a coherent policy which covers such matters as investment in film production, controls on distribution and venues, and the development of film studies. The government's major interventions have been in the quota system (attempts to limit the importing of foreign films, particularly those made in the U.S.) and in modifications of the taxation system. This is in contrast to many other countries which, like Australia, have had a clearly-formulated government policy towards the film industry, and have heavily invested in film production, or arrangements such as those in Hong Kong, where the government licenses one prolific film production company and draws revenue from it.

Attendances have been in steady decline since the early fifties, reaching a low in the early eighties. In the ten years 1972-82 there was a drop of 88% in British cinema attendance compared to a

drop of 82% in West Germany and 70% in Italy. In 1983 attendances in Britain were at an all-time low, 53,300,000. However, of its rival 'arts attractions', only museums and galleries attracted more people than did the cinema, which, through a shrunken version of its former self, was still far more popular than the theatre, opera house or concert hall.

Curiously, as it shrank, the cinema became more generally accepted as 'art'. In 1981-2 there were 557 film societies in Britain, of which 73 were in Universities and 15 at arts centres, and which had a total of 145,000 members. In the same year Rank, in announcing the closure of 29 of its cinemas, consoled itself with the thought that the closures, allied to the fact it was reducing others in size, would enable it to do more 'serious' art film work. In 1983 Cannon Classic, who had become the third largest British film company, followed the general trend by announcing that they were converting five cinemas outside London into art-house cinemas. Then, in 1985, with the industry in full retreat, the government published a White Paper *Film Policy* which was belatedly used later that year as the basis for a Film Bill. In the same year the first students took 'Film Studies' as an A Level Examination.A survey taken at the same time showed that more than a quarter of sixteen-year olds in Britain had never been to a cinema. The film business was indeed showing many of the symptoms of 'art'.

The antagonism between the 'arts world' and the media was replicated in many aspects by the history of public radio broadcasting in Britain. The British Broadcasting Company, a commercial organisation, was formed in 1922. Under its new General Manager, John Reith, it obtained a government licence in 1923 to become in effect the national broadcasting company. Once more its growth was extremely rapid. In 1922 the BBC had a staff of four and 26,000 people had radio licences; four years later the BBC had 600 staff and there were more than 2,000,000 licence- holders. Once more the rapidity of its growth caught officialdom unawares, and 'policy' was decided upon an *ad-hoc* basis. Radios had been subject to government licence from the time of the First World War, so that government could keep control of what was to them potentially a dangerous weapon; it seemed to be a positive boon to spies. In the early days of broadcasting the

radio firms in effect ran the broadcasting system on their own industrial sponsorship - because they wished the people whom they were encouraging to buy their radios to have the inducement of good regular programmes to listen to. However when the private company was, at the beginning of 1927, taken into public control, becoming the British Broadcasting Corporation, the two systems melded. The income from radio licences paid for the broadcasting service, now it had been taken out of private hands.

The content of broadcasting did not however come directly under parliament's control. The BBC was set up by Royal Charter, with control vested in a Board of Governors who were not, so long as the radio licence arrangement continued to work, dependant upon annual subvention from the government. The governors were (using a term to which we shall return in the second half of the book) 'at arm's length' from government and free to broadcast without direct government interference. However, governments *have* wished to interfere, during the war, at times of crisis in the Royal Family's affairs, at the time of Suez in 1956, and latterly with increasing frequency: the Falklands Campaign, the U.S. bombers' raid on Lybia, the coverage of the shooting of IRA men in Gilbraltar, and on many matters concerned with national security. A new committee has been set up to 'oversee' Radio and Television, the Broadcasting Standards Council. Sir William Rees-Mogg, who has 'delighted' the present Prime Minister by the way he has changed the Arts Council during his time as chairman, is to head the new body.

It is, however, also true to say that in spite of the fact that the 'British system' of running the BBC has often been quoted as a model which other countries would do well to copy, every aspect of the system is highly variable, and it is not safe to predict that any trend (towards greater government control of content, for instance) will necessarily continue for any great length of time. Nor is it even true that there has ever been a consistent view over whether the state-run organisation for broadcasting should have a monopoly, or whether the state should license a number of different agencies within a competitive framework.

The first government report on broadcasting policy, that of the Imperial Communications Committee in 1922, was never published. Nevertheless the Postmaster General informed the

House of Commons in 1922 that he accepted its recommendations and that he intended to call all the radio firms together to a meeting at the Post Office, so that they should co-operate efficiently, and so that 'there may be no danger of monopoly'. Thereafter a host of committees, the Skyes Committee (1923), the Crawford Committee (1926), the Ullswater Committee (1936) and the Beveridge Committee (1949) followed Reith's line that a monopoly of broadcasting was necessary. In Reith's own testimony to the Crawford Committee, he said:

> It is essential ethically, in order that one general policy may be maintained throughout the country and definite standards promulgated.

Beneath that unified exterior could be discerned some leanings towards a pluralistic service. In June 1930 the government refused to nationalise the private wireless relay stations, which were able to edit the programmes put out by the BBC and substitute other material from other sources. These proved quite popular. In 1939 there were 284 relay stations serving some 270,000 subscribers - and immediately after the war the number had grown to 314 stations with 865,000 subscribers, an interesting wedge of private enterprise within the state system. And in one other way was the BBC monopoly threatened. In spite of all attempts to check it, the technology outwitted the politicians, and foreign stations (particularly Radio Luxembourg) were increasingly listened to in Britain. The Plant Committee, which uttered on this in 1938, glumly pointed out that the effect of the 'Reith Sunday', when the BBC's programmes became excessively solemn, was that half the listening public tuned in to the brighter and catchier stations which, located overseas, were funded by their (often British) advertisers to beam their programmes at Britain.

It was however in the earliest days of television that the BBC monopoly was threatened. The White Paper of May 1952, issued by the new Conservative government, said that:

> The present government have come to the conclusion that in the expanding field of television, provision should be made to permit some element of competition when the calls on capital resources

at present needed for purposes of greater national importance make this possible.

In the debate on the White Paper the Home Secretary summarised the arguments for and against monopoly, as the government saw them. In favour of monopoly was the feeling that 'public service' broadcasts could not effectively stand up against competition, the fear that competition would overlook the interests of minorities and pander to the lowest common denominator, the BBC following its commercial rivals in debasing standards. Against monopoly was the fact that the present system gave the viewer no effective choice, and that there was in monopoly the danger of self satisfaction and complacency.

A great countrywide debate about the preservation or otherwise of the BBC monopoly then ensued. Defenders of the BBC included *The Times*, assorted Bishops, an array of University Vice Chancellors and the redoubtable Lord Hailsham, who found the Tory plan 'disreputable, vicious and corrupting'. Against then was ranged an equally vociferous lobby, headed by Norman Collins and including the then Prime Minister, Sir Winston Churchill. The Pluralist view made headway, and in November 1953 the government's Memorandum on Television Policy began to describe the parameters in which a competitive system might operate. This second White Paper intensified the debate - the Commons debate on it on December 15th 1953 was described by *The Times* as 'a scene of noise and confusion seldom seen in the House'. However, the pluralists won the day, and the Act establishing the Independent Television Authority was introduced to parliament on March 4th 1954 and became law on July 30th of that year. In just over a year 'commercial' television was being transmitted in Britain, its programmes interrupted at 'natural breaks' for advertising, and the monopoly of the BBC was gone for ever.

What had not of course been relinquished was government control. The position of the BBC had not altered; it still operated under government licence and, theoretically at least, without direct government interference with the content of programmes. The new ITA companies operated, very broadly, under the same conditions. The various companies operated under a franchise which was ultimately subject to government approval, and, again in theory,

were responsible for the content of their programmes. But codes of practice now multiplied; conditions relating to advertising, to the 'mix' of programmes, to the obligation to put out some government 'service' broadcasting, and much else, proliferated. In spite of it being 'at arm's length' the government had innumerable ways of applying pressure to keep television in line.

The public reaction to the new choice can readily be summarised. In October 1955, when it opened, out of 4,900,000 homes with television only six per cent could receive the new channel. Thereafter, as the number of sets receiving commercial television increased, so did the Independant Companies' share of the audience. The BBC retained the larger audience for the first three years. In 1958 the nightly share of the audience was roughly equal. By 1962, ITV claimed some 65% of the nightly viewing in the twelve million homes that then had television sets.

In that first decade, before first BBC2 and later ITV's Channel 4 had in their different ways set out to speak to the minority markets, one small but interesting statistic demonstrates how 'art' inevitably gets squeezed out of the programming for popularity. In 1956/7 the BBC devoted 3.9 per cent of its total TV output to opera, music productions and ballet. The following year the percentage dropped to 2.9 per cent, and in 1958/9 it dropped again, to 2.7 per cent, and three years later was down below 2 per cent. Nor, in spite of occasional well-publicised Opera Seasons and the like, did that situation radically change. Twenty years later the Drama and Music content of BBC2 were 4.5 per cent and 1.8 per cent respectively (compared with Sport at 15.5 per cent). Percentages in Channel 4 were better but overall the competition for the mass market was not waged by transmitting overmuch of the high arts; popularity and art were indeed assumed to be antithetical notions.

This mutual hostility worries many people. Melvyn Bragg for example bemoans the fact that the complacent believe 'it is right and proper... that the vulgar mob rule of television should be repulsed. The arts are a special preserve and best kept that way...' The two bureaucratic worlds do exist for different reasons and within different government frames, but it is not just the entrenched snobbery of the few that keeps it so, rather the deeply embedded history and practice of two different forms of control. The

apparently benign system of 'arts support' which keeps 'the arts' the province of a privileged élite, and the more obviously constraining structures which control the media of the masses, cannot simply be merged together to form one general system of communications, within one simple value system.

Technology will not stand still, and a succession of new media systems repeatedly forces government into new attempts at legislative control. Each new medium poses new problems. For example cable television produced in the mid-eighties an incredible confusion of interlocking interests. Broadcasting television did not welcome the advent of cable televison. Lord George Howard, then Chairman of the BBC, warned 'if there is unregulated cable and pay-per-view, public service broadcasting would have its financial base eroded, ITV's advertising difficulties would increase and people who were getting their entertainment on cable would be likely to say: "Why pay the Licence fee?".' But government itself was thrown into a confusion which transcended mere anxiety. Several departments were involved, including the Home Office, the Treasury, the Department of Trade and Industry and the Department of Information Technology. Committees with titles such as 'Information Technology' and 'Cable Expansion and Broadcasting Policy' were set up, uttered, dissolved and immediately forgotten. Others, such as the Hunt report, *The Inquiry into Cable Expansion and Broadcasting Policy*, were more fully debated. But no coherent policy emerged, and in Britain, one small operation alone exists as our 'Cable Television Industry'. No frame has been created for any further development and in this case 'policy' has consisted of nothing more than fractious and partisan public argument between factions of government and commercial interests. Visions of the possible general benefits cable television might have brought were not a part of the debate. It was carried on as if the *commerce* of cable televison was all that needed to be considered. 'Policy making' involved no general dialectic, no invocation of the *common sense* — it became, in a way, all too symptomatic of contemporary Britain, a furtive metropolitan debate about the economics of control.

6: By Any Other Name....

Two important aspects of the modern 'arts world' remain to be discussed. The first is that, since the middle of the nineteenth century, multiplying layers of bureaucrats have developed to attend to the licensing, taxing, controlling and 'supporting' of the arts. Second, these complex systems, which have grown ever larger as the actual constituency of the arts has shrunk, have in a curious way come to replace the idea of art itself. The actual history of artists and art is now frequently ignored, and an activity is thought to have begun only when bureaucratic activity and state intervention both focussed upon it. For example, in Britain the centuries-long tradition of young people's theatre - from the 'little eyasses' of Shakespeare's day through the public school theatres to the educational drama teams that ran in the thirties on unemployment money - is all ignored. The Arts Council announces simply (in its 1981 document *The Arts Council and Education*) that 'The Theatre in Education movement began in 1966'. Now *that* was the time when the Arts Council set up a neo-governmental bureaucracy to try to control it: it had flourished centuries earlier, and indeed the previous decade had seen many education authorities promoting strong theatre in education activity. The good people of Nottinghamshire for example must have been surprised to learn that their county education authority promoted so much theatre in education work before any of it in Arts Council terms had properly begun.

The feeling that the arts are of little significance until government bureaucracies surround them with all the paraphernalia of state support is widespread. Edmund Wilson, for example, writing in the *Wall Street Journal* in 1981, manages to imply that there was nothing in the American history of theatre, of film, of jazz, of cartooning, of literature, of radio or of television,

and that somehow the populace had ignored the poetry, the painting, the architecture and the music in their country, until...

> We came quite late to the realisation that there may be something to the arts. A mere 15 years ago the National Endowment for the Arts was founded along with the National Endowment for the Humanities. Most state arts councils are even younger.

The 'something' which was given to the arts with the new realisation can be identified quite easily. A selective application of government grant aid, which is sometimes genuinely helpful and sometimes simply distorts a natural arts market, is given within very tightly circumscribed boundaries. To administer this a complicated bureaucratic system in created, which has two segments: 1) a bureaucracy administering the grant system, and 2) a responding bureaucratic organisation within the organisation itself which shapes and presents accounts and objectives in a way the funding body approves of, fills in the forms, attends meetings, redescribes the funding body's decision to the arts organisation and the artists, and generally acts as the government 'plant' within the client organisation. The 'something' the 'new realisation' offers to the arts in America is *bureaucracy*.

Of course it can always be said in a mixed economy that arts organisations have no need to join the subsidised sector, and that is true for large parts of the arts economies in the United States as it is in Britain, Canada, Australia and many other English-speaking countries. Yet that is to ignore the way in which sometimes arts subsidy applied to one part of a market will so distort the remainder that the supposedly free commercial institutions will be forced to contend with the state system. To take one example. The Arts Council in Britain once brought out, for two years, a pleasant, heavily subsidised literary magazine, which published poetry, short stories, literary reviews and the like. In three ways it gravely affected the *other* little magazines that until then had a niche within the very small market for this kind of work. First, it paid contributors well and so attracted them away from the others. Second, it heavily subsidised both its price and the cost of distribution, so it ate into the others' markets quite heavily. Third, it attracted away the advertisers who, though they had not paid much to appear in rival magazines, had made the difference between success and failure.

In that two years a number of magazines closed, and those that did not were in some cases forced into begging for grant aid, thus moving them into the state support system.

The danger is always that the commercial organisation, which finds itself in competition with state subsidised activities, will when finally forced to apply for subsidy, have so organised itself over a long period of time that it will not fit any of the bureaucratic criteria for support and so its life will be abruptly terminated. That happened in Britain to the D'Oyly Carte Opera Company, which after a century of commercial success, found itself paring down production costs to maintain itself as a touring opera company in theatres which, because they normally presented subsidised opera, charged prices that were too low for them. That paring of costs caused standards to drop because their heavily subsidised rivals were able to pay much more for orchestral players of quality, and to pay much more for good singers. When they eventually applied for grant aid, they were refused *because* their standards were thought to be too low and because, amongst much else, their scenery seemed 'old fashioned'.

To return to the United States, it is salutary to look at the kind of bureaucracy through which an applicant must try to pass. Suppose we look briefly at one field in which America has long been pre-eminent, and in which for decades it had supported work wholly commercially, that of dance. Suppose we look at a small dance company which has kept itself alive commercially for a year or two but which now, finding itself in competition with subsidised companies, feels that it must apply for a grant from the NEA. First, it has to fill in Form NEA in triplicate, together with two Supplementary Information Sheets (Figure 1, pp. 52-61). This has to be done well in advance of the period for which the grant is requested, and has to be done in the light of 28 pages of instructions from the NEA on what may and may not be included. As will be seen, to fill in the form requires an extremely detailed ability in forward-planning; knowledge of all the equipment that is going to be required, salary costs for all administrators, technicians and artists, all fees, all travel costs, and of course an estimation of the projected income from all sources. This is in itself a lengthy, time-consuming and expensive exercise for the applicant. However three forms are duly completed and are submitted, together with

Dance

Project Grant Application Form NEA–3 (Rev.)

This application form must be submitted in triplicate and mailed to:
Grants Office/DAN, 8th floor, National Endowment for the Arts, Nancy Hanks Center, 1100 Pennsylvania Avenue, N.W., Washington, D.C. 20506

I. Application Organization (name, address, zip)	II. Category under which support is requested:	III. Period of support requested:

I. Application Organization (name, address, zip)

Artistic Director _____
Executive Director _____

II. Category under which support is requested:

☐ Dance Company Grants
☐ Grants to Dance Presenters
☐ Dance/Film/Video
☐ General Services to the Field

III. Period of support requested:

Starting _____
month day year
Ending _____
month day year

IV. Summary of project description (in this space, specify clearly how the requested funds will be spent.)

V. Estimated number of persons expected to benefit from this project.

VI. Summary of estimated costs (recapitulation of budget items in Section IX)

Total costs of project (rounded to nearest) ten dollars)

A. Direct Costs
　Salaries and wages _____ $ _____
　Fringe benefits _____ _____
　Supplies and materials _____ _____
　Travel _____ _____
　Permanent equipment _____ _____
　Fees and other _____ _____
　　　　　　　　　Total costs $ _____
B. Indirect costs _____ $ _____
　　　　　　　　Total project costs $ _____

VII. Total amount requested from the National Endowment for the Arts $ _____
(not to exceed 50% of Total project costs)

VIII. Organization total fiscal activity

	Fiscal year ending /1985		Estimated for Fiscal year ending /1986		Projected for Fiscal year ending /1987		Projected for Fiscal year ending /1988	
	month	year	month	year	month	year	month	year
A. Expenses	1. $ _____		2. $ _____		3. $ _____		4. $ _____	
B. Revenues, grants, and contributions	1. $ _____		2. $ _____		3. $ _____		4. $ _____	

IX. Budget breakdown of summary of estimated costs **2**

A. Direct costs

1. Salaries and wages

Title and/or type of personnel	Number of personnel	Annual or average salary range	% of time devoted to this project	Amount $

Total salaries and wages	$
Add fringe benefits	$
Total salaries and wages including fringe benefits	$

2. Supplies and materials (list each major type separately) Amount $

Total supplies and materials	$

3. Travel

Transportation of personnel Amount

No. of travelers	from	to	$

Total transportation of personnel	$

Subsistence

No. of travelers	No. of days	Daily rate	$

Total subsistence	$
Total travel	$

IX. Budget breakdown of summary of estimated costs (continued) **3**

 4. Permanent equipment

	Amount
	$
Total permanent equipment	$

 5. Fees for services and other expenses (list each item separately)

	Amount
	$
Total fees and other	$

B. Indirect costs

Rate established by attached rate negotiation agreement with
National Endowment for the Arts or another Federal agency

Rate _____% Base $ _____ Amount $ _____

X. Contributions, grants, and revenues (for this project)

 A. Contributions

 1. Cash

	Amount
	$

 2. In-kind contributions (list each major item; must correspond to an expense item under Section IX)

Total contributions	$

 B. Grants (do not list anticipated grant from the Arts Endowment)

	$
Total grants	$

 C. Revenues

	$
Total revenues	$
Total contributions, grants, and revenues for this project	$

XI. State Arts Agency notification **4**

The National Endowment for the Arts urges you to inform your State Arts
Agency of the fact that you are submitting this application.

Have you done so? _____ yes _____ no

XII. Certification

We certify that the information contained in this application, including all attach-
ments and supporting materials, is true and correct to the best of our knowledge.

Authorizing official(s)

Signature X _____ Date signed _____
Name (print or type) _____
Title (print or type) _____
Telephone (area code) _____

Signature X _____ Date signed _____
Name (print or type) _____
Title (print or type) _____
Telephone (area code) _____

Project director

Signature X _____ Date signed _____
Name (print or type) _____
Title (print or type) _____
Telephone (area code) _____

*Payee (to whom grant payments will be sent if other than authorizing official)

Signature X _____ Date signed _____
Name (print or type) _____
Title (print or type) _____
Telephone (area code) _____

*If payment is to be made to anyone other than the grantee, it is understood that
the grantee is financially, administratively, and programmatically responsible for
all aspects of the grant and that all reports must be submitted through the grantee.

BE SURE TO CHECK THE "HOW TO APPLY" SECTION FOR YOUR
CATEGORY FOR ALL MATERIALS TO BE INCLUDED IN YOUR
APPLICATION PACKAGE.
 See pages 11–12 for Dance Company Grants
 See pages 14–15 for Grants to Dance Presenters
 See pages 17–18 for Dance/Film/Video
 See pages 20–21 for General Services to the Field

Dance Presenters Supplementary Information Sheet
Fiscal Year 1987

1. Applicant Organization: _____ City: _____ State: _____
 Year founded: _____ First year as a presenter: _____ Telephone: _____
2. Executive Director: _____ Project Director: _____

3. [] Fill in this box with the category code that best describes the primary function of your institution. If your institutional type is not among those listed, please indicate 47—Other, and add a brief description.

 07 Performance facility 14 Festival 26 College/university
 08 Museum—art 15 Art center 47 Presenter without facility
 10 Gallery/exhibition space 16 Arts council/agency 47 Other _____

4. Name below the primary facilities in which you present, and select the category code that best describes each from the list below. Also indicate stage size, seat capacity, and ownership status for each.

 01 Traditional proscenium theater with fly loft space 04 Thrust stage theater
 02 Traditional proscenium theater without fly loft space 05 Arena stage theater
 03 Proscenium theater convertible to thrust 06 Flexible black box theater
 07 Multi-purpose auditorium with fly loft space 09 Lecture hall with permanent stage
 08 Multi-purpose auditorium with stage but no fly loft space 11 Gymnasium
 15 Outdoor amphitheater or concert shell 18 Recital hall
 19 Other (A) _____ (B) _____ 19 Flexible exhibition space

Name	Type		Stage Size	Seating Capacity*	Owned or Rented
A. _____	[]	w ___ x d ___		_____	_____
B. _____		___ x ___		_____	_____
C. _____	[]	___ x ___		_____	_____

5. Do you have rehearsal space available? [] yes [] no *or running feet for exhibition space
6. Stage floor composition: [] sprung wood [] wood over concrete [] tile over concrete [] concrete
 [] other (specify) _____

NOTE: Questions 7–15 relate only to PRESENTATION ACTIVITIES (i.e., touring shows, performing companies based outside your facility, etc.). Please do not include production or service activities.

7. Revenues and expenses allocated for professional arts presentations (do not include produced events):

	85/86 Season		86/87 Projection	
	Dollar Amount	Percentage	Dollar Amount	Percentage
REVENUES				
Ticket revenues	$	%	$	%
Other earned income (include rentals here)				
Federal government				
Other government				
Individuals				
Corporations and foundations				
Host Institution/Interest from institution's endowment				
Total revenues	$	100%	$	100%
EXPENSES				
Artist fees (including travel and lodging)				
Wages and contracts (personnel)				
Advertising, promotion, publicity				
Other back and front of house costs				
Other administrative costs				
Total expenses	$	100%	$	100%
Year end balance (Revenues minus Expenses)	$ _____		$ _____	

8. Estimate the dollar value of in-kind contributions donated to your institution for:
 the 85/86 season $ _____
 the 86/87 season $ _____ (projected)

Dance Presenters Supplementary Information Sheet
Fiscal Year 1987 (continued) — Applicant organization: _____

PLEASE NOTE: Do not include rentals or produced events for any items on this page.

9. Attendance Statistics: (Exhibitions and outdoor events should enter NA in capacity boxes)

84/85 Season

Total Paid Attendance

Total Unpaid Attendance

Total Attendance ÷ Season's Total Capacity = % of overall Capacity %

85/86 Season

Total Paid Attendance

Total Unpaid Attendance

Total Attendance ÷ Season's Total Capacity = % of Overall Capacity %

10. What was your income from subscriptions in 84/85? $_____ 85/86? _____

11. Ticket prices: Highest (non-benefit) ticket price in 84/85 $_____ Lowest ticket price in 84–85 $_____
85/86 $_____ 85–86 $_____

12. Average ticket price:

Total ticket revenue (85/86) ÷ Total paid attendance (85/86) = Average ticket price

13. Indicate the total number of professional presentations (i.e., performances) in each discipline for your 85/86 season, and the number of professional engagements/contracts (i.e., companies, solo artists, or exhibitions) this represents.

Number of Presentations	Number of Engagements			Number of Presentations	Number of Engagements		
		Ballet 01A	DANCE			Chamber 02B	MUSIC
		Ethnic/Folk 01B				Choral 02C	
		Modern 01C				Contemporary/New Music 02D	
		Post Modern 01				Ethnic/Folk 02E	
		Jazz/Tap 01D				Jazz 02F	
NA		Film 09A	MEDIA			Popular(includesrock)02G	
		Radio 09B				Solo/Recital 02H	
		Television 09C				Symphonic 021	
		Video 09D					
		Classical 04A	THEATER			Interdisciplinary Performance Art 05E	OTHER
		Modern 04A				Opera 003	
		Experimental 04A				Musical Theater 04C	
		Mime 04B				Literature 010	
		Puppet 04D				Traditional Folk Arts (Other than Music and Dance) 012	
		For Young Audiences 04E					
NA		Conceptual Art 05A	VISUAL ARTS	NA		Painting 05D	VISUAL ARTS
		Graphics 05B				Sculpture 05F	
		Inter-Media 05C				Crafts 007	
						Photography 008	

14. Total number of presentations: _____ Total number of engagements: _____

15. Beginning and ending dates of 85/86 season
Date of first presentation ___ / ___ / ___ Date of last presentation ___ / ___ / ___

Dance Company Supplementary Information Sheet—Fiscal Year 1987

The Dance Program needs the information requested on this form for panel review and in order to develop more complete statistics about dance companies. Complete all items as accurately as possible. If you need explanation of any items, please call the Dance Program at 202/682-5435.

Legal name of organization _____

Popular name, if different from legal name _____

Type of company (check only one):

Ballet ☐ Modern ☐ Ethnic ☐ Jazz/Tap ☐ Other ☐ Specify _____

Name of person completing this form _____ Phone number _____

I.	SEASON LENGTH	84–85	85–86	86–87	87–88
A.	Weeks of self-produced performances (include any week in which such a performance occurred)				
B.	Weeks during which company was paid a fee for services				
C.	Weeks during which company rehearsed & did not perform or earn service fees				
D.	Other weeks (specify)				
E.	Total number of weeks in season (A–D combined)				
II.	**PERFORMANCES**				
A.	Number for which a contracted fee was paid 1. in home city				
	2. on tour in US				
	3. on tour outside US				
B.	Number self-produced 1. in home city				
	2. on tour in US				
	3. on tour outside US				
C.	Total number of performances (A & B combined)				
III.	**MISCELLANEOUS**				
A.	Number of non-performance services (master classes, lecture-demonstrations, etc.)				
B.	Number of performances with live music				
C.	Number of new productions				
D.	Number of choreographers whose work is performed				
E.	Ticket price for self-produced performances 1. Highest (non-benefit) price	$	$	$	$
	2. Lowest (discounted) price	$	$	$	$
F.	Personnel 1. Number of artistic personnel (excluding dancers)				
	2. Number of dancers normally associated with company				
	3. Number of apprentices				
	4. Number of administrative personnel				
	5. Number of technical personnel (normally associated with company)				
	6. Number of school personnel (administrative and faculty)				
	7. Number of musicians				
	8. Number of other personnel—specify				

Dance Company Supplementary Information Sheet (continued)

IV.	REVENUE		84–85	85–86	86–87	87–88
	A.	**Earned**				
		1. Revenue from self-produced domestic performances	$	$	$	$
		2. Total revenue for domestic performances and services for which company was paid a fee	$	$	$	$
		3. Revenue from foreign performances and services	$	$	$	$
		4. School tuition and fees	$	$	$	$
		5. Boutique sales	$	$	$	$
		6. Interest/endowment income	$	$	$	$
		7. Other—Specify	$	$	$	$
		8. **Total Earned Revenue (1–8 combined)**	$	$	$	$
	B.	**Contributed**				
		1. State government	$	$	$	$
		2. Local government	$	$	$	$
		3. Corporations	$	$	$	$
		4. Foundations/trusts	$	$	$	$
		5. National Endowment for the Arts a. Dance Program	$	$	$	$
		b. Other Programs—specify	$	$	$	$
		6. National Endowment for the Humanities	$	$	$	$
		7. Other—specify	$	$	$	$
		8. Individuals	$	$	$	$
		Total Contributed Revenue (1–8 combined)	$	$	$	$
	C.	**Total (this should equal co's total income for the year, Items A and B combined)**	$	$	$	$
V.	**EXPENSES**		84–85	85–86	86–87	87–88
	A.	**Salaries and Wages (including fringe benefits)**				
		1. Artistic personnel (excluding dancers)	$	$	$	$
		2. Dancers normally associated with company	$	$	$	$
		3. Apprentices	$	$	$	$
		4. Administrative personnel	$	$	$	$
		5. Technical personnel (normally associated with company)	$	$	$	$
		6. School personnel (administration & faculty)	$	$	$	$
		7. Others—specify	$	$	$	$
		8. **Total of salaries & wages (1–7 combined)**	$	$	$	$
	B.	**Fees for Artistic Personnel**				
		1. Guest choreographers	$	$	$	$
		2. Guest dancers	$	$	$	$
		3. Other guest artistic personnel (designers, etc.)	$	$	$	$
		4. Musicians	$	$	$	$
		5. **Total fees for all artistic personnel (1–4 combined)**	$	$	$	$
	C.	**Non-Performance Production Expenses (video, costumes, sets, etc.)**	$	$	$	$
	D.	Performance Service Expenses (including travel, publicity, equipment and theater rental, & personnel such as stagehands; do not include expenses listed in items A., B., & C.)				
		1. Expenses for performance/artistic services for which company was paid a fee	$	$	$	$
		2. Expenses for self-produced performances	$	$	$	$
		3. Expenses for foreign performances and services	$	$	$	$
		4. **Total Performance/Artistic Services Expenses (D.1–3 combined)**	$	$	$	$
	E.	School expenses (excluding personnel)	$	$	$	$
	F.	General & Administrative (rent, utilities, consultant fees, etc.)	$	$	$	$
	G.	Other—specify	$	$	$	$
	H.	**Total (this should equal company's total expenses for the year, Items A–G combined)**	$	$	$	$
VI.	**SURPLUS (DEFICIT)**		$	$	$	$
VII.	**ACCUMULATED SURPLUS (DEFICIT)**		$	$	$	$

(Any budget growth of more than 20% per year should be explained in a brief narrative.)

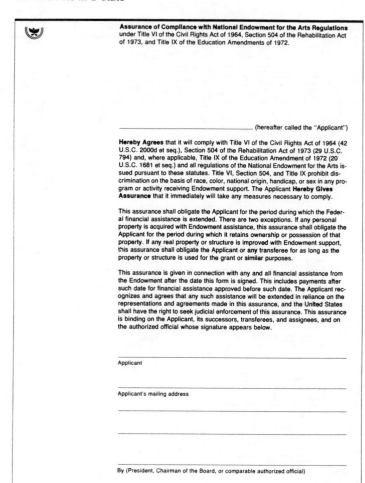

Assurance of Compliance with National Endowment for the Arts Regulations under Title VI of the Civil Rights Act of 1964, Section 504 of the Rehabilitation Act of 1973, and Title IX of the Education Amendments of 1972.

_____ (hereafter called the "Applicant")

Hereby Agrees that it will comply with Title VI of the Civil Rights Act of 1964 (42 U.S.C. 2000d et seq.), Section 504 of the Rehabilitation Act of 1973 (29 U.S.C. 794) and, where applicable, Title IX of the Education Amendment of 1972 (20 U.S.C. 1681 et seq.) and all regulations of the National Endowment for the Arts issued pursuant to these statutes. Title VI, Section 504, and Title IX prohibit discrimination on the basis of race, color, national origin, handicap, or sex in any program or activity receiving Endowment support. The Applicant **Hereby Gives Assurance** that it immediately will take any measures necessary to comply.

This assurance shall obligate the Applicant for the period during which the Federal financial assistance is extended. There are two exceptions. If any personal property is acquired with Endowment assistance, this assurance shall obligate the Applicant for the period during which it retains ownership or possession of that property. If any real property or structure is improved with Endowment support, this assurance shall obligate the Applicant or any transferee for as long as the property or structure is used for the grant or similar purposes.

This assurance is given in connection with any and all financial assistance from the Endowment after the date this form is signed. This includes payments after such date for financial assistance approved before such date. The Applicant recognizes and agrees that any such assistance will be extended in reliance on the representations and agreements made in this assurance, and the United States shall have the right to seek judicial enforcement of this assurance. This assurance is binding on the Applicant, its successors, transferees, and assignees, and on the authorized official whose signature appears below.

Applicant

Applicant's mailing address

By (President, Chairman of the Board, or comparable authorized official)

Dated

Assurance Explanation

Title VI of the Civil Rights Act of 1964 provides that no person in the United States shall, on the grounds of race, color or national origin, be excluded from participation in, be denied the benefits of, or otherwise be subjected to discrimination under any program or activity receiving Federal financial assistance. Section 504 of the Rehabilitation Act of 1973 provides for nondiscrimination in Federally assisted programs on the basis of handicap. Subject to certain exceptions, Title IX of the Education Amendments of 1972 prohibits the exclusion of persons on the basis of sex from any education program or activity receiving Federal financial assistance.

As a condition to approval of a grant, Arts Endowment regulations require all organizational applicants to execute the "Assurance of Compliance" form, whether or not a comparable form has been filed with another agency.

The Applicant referred to in the form is the organization itself, whose chief executive officer or comparable official should sign. The name and title of the organization and of the official should be typed on the form. The signed original should be returned with other required materials to the Arts Endowment's Grants Office. It should be noted that signing this form indicates a commitment to comply with the three statutes referred to herein.

NATIONAL ENDOWMENT FOR THE ARTS

WASHINGTON D.C. 20506

A Federal agency advised by the
National Council on the Arts

APPLICATION/GRANT PROCESS

Applicant/ Grants	Endowment Offices	Advisory Panels	National Council on the Arts	Procedure
	●			Program Director, in consultation with advisory panel members/experts in the field, National Council on the Arts, and the Chairman of the National Endowment for the Arts, prepares Guidelines announcing grant programs, eligibility for application, application deadlines.
●				Grant program announcements and Guidelines are published, provided to all organizations of known capability, and distributed to a wide mailing list, which includes libraries and press outlets. The Arts Endowment also publishes and distributes the Guide to the National Endowment for the Arts. Brief descriptions of all Programs are published in the annual Catalog of Federal Domestic Assistance sold by the Government Printing Office.
	●			Potential applicants respond to program announcements and request Guidelines with application forms if they do not already have them.
●				Program Offices or Public Information Office responds to requests and provides Application Guidelines to potential applicants. Applicants review Guidelines and prepare the formal applications.
	●			Applicants submit formal applications. Copy of IRS letter, attesting to an organization's tax-exempt status, must accompany application.
	◉			Applications are reviewed by Program Offices to make sure materials are complete. Reviewed applications are presented to advisory panels for review and recommendation.
		◉		Advisory panels, whose members are professionals from the field, review all applications that fall within the Program Guidelines and comply with the required eligibility and IRS status. Panels recommend those applications to be funded and those to be rejected.

Applicant/ Grants	Endowment Offices	Advisory Panels	National Council on the Arts	Procedure
	●			Panel suggestions can be incorporated into the proposed grant. Sometimes, for example, an applicant's budget must be revised; and in these cases, the panel comments are reviewed with the applicant by the Program staff.
			◉	Applications, with all panel recommendations for funding and rejection, are presented to the 26 member National Council on the Arts, which reviews the applications again and makes further recommendations.
	◉			The Chairman, on the basis of recommendations from the National Council on the Arts, approves the applications for assistance. Program Offices, in consultation with the Grants Office, prepare grant letters for the Chairman's signature. The Chairman, or his designate signs grant award letters signifying approval of the grants. (Program Directors send letters to rejected applicants.)
●				A signed grant letter is forwarded to potential grantee.
●				Grantee submits initial request to Grants Office for cash payment and by signing signifies acceptance of the grant and its conditions. Subsequent payments are submitted in accordance with terms of the grant.
	◉			Grants Office staff reviews request for each cash payment.
●				Cash payments are authorized and forwarded to grantee.
●				Grantee completes project and submits Final Descriptive and Expenditure Reports to the Grants Office.
	◉			Staff reviews and approves final reports and closes out grant.
◉				Audit of grantee is conducted, if appropriate.

● = Operation: To prepare or refer to document. To complete an application, for example.

◉ = Review: To check an application or report for quality, accuracy, and compliance.

an Assurance of Compliance with National Endowment for the Arts Regulations.

The bureaucratic stages now multiply. The NEA's own chart (Figure 2, pp. 62-3) identifies seventeen discrete stages in the process, but some of these break down into many further stages. The 'audit of grantee' for example can itself occupy some considerable time and involve a number of further processes. And nothing has yet been said about the informal meetings, the exchanges of letters, the telephone calls, the lobbying and the discreet words dropped in shadowy ears that accompany some if not all of these stages. The cost of making the application is high to the would-be client; the expense to the funding organisation (whether it accepts it or no) is also very great. Hundreds, if not thousands, of dollars are spent in simply processing each application, and tens of hours are spent by bureaucrats within the funding organisation and the client organisation *before any decision is taken about giving a grant*. In some cases of course the grant when given does no more than pay for the bureaucratic expense of getting it.

If our small dance company is successful, however, it now faces the second phase of bureaucratic activity involved in being a state-supported client. Having expended much time and effort on application, it will now have to face a further expenditure on control — arranging the grant-aided activities in such a way that the company complies with the conditions of the grant — the right technical standards, the right administrative procedures in employment and in financial control, and the right artistic policy of course.

In attaining the right *technical* standards the company is likely to find, if it has not already done so, that the modern 'arts' have a tendency which runs counter to the industrial activities with which they are often compared. It is that as the technology improves, the arts employ *more* people, not fewer as is usually supposed to be the case. Dramatic illustration of this process at work in the U.S. comes from Hilda Baumol and W.J. Baumol, in a paper published in 1985. W.J. Baumol and Bowen have long been misquoted as having stated ('Baumol's disease') that it is an inexorable law of performing arts organisations that as they are so labour-intensive their costs *must* outrun inflation. In fact they observed only that it

was a phenomenon of orchestral costs in the U.S. at a certain stage of an economic cycle, and that it did *not* seem to work in periods of high inflation. However, twenty years later, working with his wife, Dr Baumol has given a useful insight into the actual nature of 'labour-intensiveness' in the performing arts, and has thus pinpointed something which our dance company would have to face — that being a client of grant aid means that you have to spend much more on administration and technicians, in order to fit in with the 'standards' now expected.

The Baumols' figures are derived from a study of 22 performing arts organisations working in the U.S. regional theatre, and they are summarised as follows:

Distribution of expenditure in U.S. performing arts companies

	1974	1978	1983	Difference
Artistic Salaries	26.9	28.9	24.6	−9%
Administrative Salaries	13.7	15.7	18.9	+38%
Technical Salaries	11.4	13.4	14.8	+30%
Non-salary expenditure	47.9	42.3	41.8	−13%

The 'standards' asked of a subsidy client will involve, in all probability, the hiring of sound technicians (it is a curiosity that the advent of sound technology has led even companies specialising in dance not just to buy it and make use of it, but to hire sound technicians to operate it - or centuries theatre, opera and of course dance ran without any such animal.) They will ask for the purchasing of more lighting equipment - the numbers of lights needed to illuminate simple open stages, all that can be managed sometimes on the remaining budget, is mind-boggling - and of course the hiring of special lighting designers and more electricians and lighting experts. (Some theatres increase the lighting staff at the same time as they buy computerised switchboards with full memory systems.) They will be gently pressured into buying word processors and computers that 'talk to' the others on the subsidised circuit (and again, computerising office or box office systems seem to lead usually to hiring more staff, not fewer). Then, to fill in the

returns, to control the daily flow of cash and invoices in the approved manner, and to fashion the employment within the organisation so that it fits the current 'priorities' of the funding body -the right ethnic mix, the officers having the modish titles, the correct balance between the sexes, to say nothing of the central fact that funding depends upon employing directors and artists favoured by the bureaucrats — all that involves the taking on of more administrative staff. It is in these areas which all evidence suggests the labour-intensity exists -administrative and technical costs within the client organisation will probably have increased by more than thirty per cent over the last decade. The artists, right at the tail end of all this bureaucratic activity, get a decreasing part of the available money.

Indeed it is possible to argue that in many cases the entirety of government subvention in the arts goes to the bureaucrats and the bureaucratic systems concerned with subsidy, and that when governments increase the 'arts' grant, bureaucracy expands to take up the slack. There are many organisations in which the technical and administrative costs involved in working to the subsidising body's 'standards' equal the total grant in aid. (In the Baumols' figures quoted above administrative and technical salaries amount to a third of costs which is normally the largest percentage in grant aid that the NEA will give.) There are even more organisations in which the proportion spent on administrative and technical salaries rises proportionately in excess of increases in grant aid. In *all* arts organisations, it is fairly safe to say, there are proportionately more non-artists and non-performers employed than there were thirty years ago, and expenditure on actual arts presentations has decreased in inverse proportion to the rise in expenditure on grant-getting and grant-management.

Arts councils in general have in recent years taken on an appropriately bureaucratic form. It is now clear that these organisations are expecting to deal with other bureaucracies -their managers, operations managers, systems analysts, development officers and the like expect to deal with other bureaucrats. They have replaced the old theatre officers, music officers and the like, because they do not expect nowadays to focus upon artists and art, only upon the business of art and its sprawling bureaucracy. Their reports now make this perfectly plain.

The most recent report of the British Arts Council (Number 42, 1987) will do as well as any other by way of illustration. Although it has a few pictures of art and artists to give it a sheen of sophistication, the text reads like a bureaucrat's picnic. Every department of the Council rejoices not in art of the old- fashioned kind, what artists do, but in the *new* art, the bureaucratic explosion. Thus Combined Arts gives as its big news the fact that a new committee was formed at the beginning of the year, the Drama department rejoices in the fact that a big new drama report has been written and published, the Literature Department tells us tartly that its big news is that its formulated a new policy (neglecting to mention the derision it received from novelists, publishers and poets in general) and The Touring Department has reorganised its own office procedure. The Planning Department has not got anything quite so positive to report but keeps its bureaucratic end up by announcing it has experienced its first year of existence.

To an outsider it may not appear obvious why administrative costs within an arts council should rise so very dramatically when the government grant in aid to them rises - why, in a word, it should cost them so very much more to process the same number of applications. Unless of course, as we hinted above, bureaucracies have a tendency to expand to take up any financial slack. It would certainly seem to be the case in Britain. At the time of Baumols' research the percentage of Arts Council expenditure for administration rose from 4.2% to 4.9%. The number of clients actually declined.

And within that same period that insidious tendency to refer to the bureaucracy as if it *is* the Arts grew apace. It was led by the Arts Council itself, which consistently referred to the various projects with which it was involved as if they were to be defined as art, as examples of *enterprise* in art, if their bureaucratic and financial support systems were correct. Like the dreadful 'Brick Man' (Chapter 10.7, and see cover picture) things become 'art' when they are produced as a result of the approved mix of monies from government and from private enterprise, local authorities and trusts. A statue, however hideous, put up in order to startle visitors to Leeds Railway Station becomes 'art', and gets space in Arts Council's reports to the nation, and is assumed, because

bureaucrats have temporarily agreed about the money, to be meeting some kind of 'need'. The figure of the laughing old fisherman which greets visitors to the Lincolnshire resort of Skegness is by contrast a hideous vulgarity. It is 'funded' by the wrong people — just local authorities and local commerce. It therefore isn't art. Moreover the people who see it are holidaymakers, not tourists. And because it has been a breezy symbol of Skegness for more than half a century and the town's visitors *want* to see it, it cannot be ministering to the unarticulated needs which the arts bureaucrats know they've got. 'Brick Man' is therefore a perfect example of bureaucratically-defined art, in the modern sense, while the Jolly Fisherman is a commercial abomination.

It might perhaps be helpful to try to see the 'Brick Man' as a turning point - the nadir of the drift in Britain (and in some overseas countries) towards seeing 'the arts' as bureaucratically-defined *goods*, a drift which has been characterised by an increase in bureaucratic control, a stifling of real artistic work, a decline in general critical rigour, and a revolting meanness of spirit. The plain ridiculousness of saying that 'Brick Man' is 'art' (and therefore a product which is attracting tourists and helping Leeds' inner city regeneration) must be apparent even to those who were saying, with Dr Timothy Pascoe, that 'the arts are a business *like any other*, or saying, with the management team of the British Arts Council that the arts were 'simply' products, 'a small part' of 'Great Britain Inc.', and that 'the arts are not different' from other goods. Viewed in that light it is encouraging rather than anything else that some Leeds Councillors have refused to believe in the clothing which was supposed to be hiding the Brick Man's nakedness, and have suggested that there may be more urgent things to spend money on.

For the arts *are* manifestly different from other goods. 'They' do not exist just by virtue of being produced, as do goods; they require the nurturing of critical debate to be intelligible, above all they need the understanding of a common sense to have real value. Nor are the arts *services*. Services exist to minister first and foremost to clearly articulated wants. Moreover services can only exist when there is a clear system of signalling those wants in advance. 'The arts' have, in their modern definition, moved too far from

acknowledging that the public should have its choices about what gives meaning and pleasure to life recognised. But it is a far cry from saying that its wants should be taken notice of to saying that a service system for the arts can be built up - for such wants may never be apparent in advance. There has to be freedom for endless experiment, endless commercial trial, as well as a system for responding to the articulated wants when they do become clear. We cannot know whether there will not be a great surge of interest, five years from now, in lyric poetry, in ice skating pantomimes, in stump oratory, in masques, in gymnastics, in preaching, or in lute playing. We cannot plan a *service industry* that will realise equal opportunities to enjoy all the various creative activities that might, even in a short time, have been vested with significance by some unforeseeable shift in public taste and interest. We cannot, as our British Arts Council has attempted vainly to do, try to 'equalise opportunity' or 'minimise distortion', because countries, regions or decades cannot be compared against a calibrated scale that permits of any such adjustment. They are *different*. Neither goods nor services, but *art* – and art exists within different cultures, with different values bestowed upon each part of it by different critical processes, and is finally composed of thousands of *separate* acts of understanding and joy.

We have to return to the point we made in our short discussion of the classical civilisations. The meeting place of art and government is in critical debate - a debate which recognises the legitimate right of art to speak both in its Dionysian form and its Apollonian, and which recognises that the artist does not have an automatic right to be heard, but one given by open critical judgement, by the common sense. The arts world needs to recognise its communality with government, its necessary contribution to debates about how life should be lived, and governments in their turn need to recognise that their artists are neither goods nor services, but citizens with particular and important functions. We shall turn now to a more analytical examination of government policies and government motives in 'supporting' art.

THE PRESENT

7: Government Control

Governments of advanced countries are usually described as offering 'support' to the arts through subsidies. Nevertheless the wider purposes of government more often involve constraining arts markets. That constraint, which may be either good or bad in nature, lies within four main areas, (i) licensing law, (ii) taxation systems, (iii) state education and training systems, and (iv) censorship, direct and indirect. As state subsidy systems must work within the legal and fiscal framework of this accumulated legislation, it is hardly surprising that subsidy systems themselves can readily become a fifth means of government control.

In saying that the great mass of government legislation bearing upon the training of artists, and the various micro economies of the arts world, is *constraining* in nature, we are not assuming that all such government actions are wicked or philistine. Few people think, for example, that anyone with a fancy to be poet or a painter has the automatic right to be trained at the public's expense; most people would accept that there must be constraints on entry to training courses. Likewise, few people would suggest that even a trained artist has the automatic right to be seen and heard, whatever is produced; to believe that would be to force the public into compulsory attendance at all kinds of art events, and we believe that freedoms for artists must be balanced by freedom of choice for consumers. Where modern states have tried to make it a right for artists to be seen and heard, they have generally been made to look ridiculous by the public. The European belief that playwrights must be assisted by the state for the first performance of their work, which goes back some thirty years, has for example left the EEC countries with a Play Mountain of once-produced works, as wasteful of human energy in its way as the better known Butter Mountain. In Holland, where for some years the state purchased all fledgling work by newly trained artists, there are still

hangers filled with thousands of decaying, unseen pictures, a sad little monument to the government's well-intentioned desire to remove the customary market constraints on the purchasing of art.

The picture is made the more complicated by the fact that much legislation which bears upon the arts markets does not have them as a prime target. Legislation over the right of public assembly, of free speech or of unrestricted travel may have unforseen consequences for the arts. Legislation over public safety, which may have industry as its major target, may still seriously disturb a part of the arts world — as, for example, legislation over the siting of crush barriers has frequently disturbed theatre managements in Britain, demanding that they site the barriers at the very spot where they will restrict the view of the stage. The field of national and local taxation offers many examples. Sometimes it will be the case, as in Singapore, that taxation systems designed to regulate the flow of imported and exported goods and services will make it quite difficult to arrange incoming tours by musicians or theatre companies. At times, however, a tax concession designed to help *another* sector of the economy can with advantage be made to apply to arts organisations; one of many examples comes from Canada, where arts organisations have sometimes found it useful to register themselves as Crown Corporations, and thus gain the tax advantages intended for other kinds of public charity institutions.

The first section of this book has given some indication of the complexity of governments' interference, benign or otherwise, in the processes by which artists meet their audiences. That is our inheritance; we cannot shake ourselves free of the past. The laws by which artists meet the public, the traditions which those laws have helped to shape, and the accumulated arts which form our cultural inheritance (which in their turn were constrained by those laws and by those traditions) are deeply and inextricably ingrained in our lives. A new subsidy system, a new 'strategy' from an Arts Council, new reforming legislation or anything else that we may proudly term an 'arts policy' is in truth likely to be ultimately only of marginal significance. Even totalitarian governments, dedicated to total interventionism and the eradication of privacy, have found throughout the twentieth century that traditional cultures are

weirdly resilient, capable of being changed only by the slow accretion of legislative control, not by instant decree.

That accretion of fiscal, legal and educational control has built up over time, has interacted with artists and their works, to form the means by which new art may be understood and the means by which it may be evaluated and enjoyed. After the revolution, Russians continued to understand the plays of Chekhov by virtue of Russian cultural traditions, not because of their new Marxist ideology. All art, however new it may seem, is finally understood by virtue of the traditions which give it meaning and significance; the Impressionists would not just have been startling, but incomprehensible, without the rich traditions of nineteenth century European landscape painting. The nature of art is thus fixed and of a nature that 'support' in the shape of short-term, small-scale subsidy can do little to change. Subsidy systems tend therefore to be the fine tuning of a system supporting the well-established, promoting safe activities which are a part of the way governments in general want things to be. Government systems of arts subsidy rarely support for very long those activities which fly in the face of tradition, or which seek to break free of general government constraints; government has too many other means of constraining the arts for such a course to be either prudent or likely to succeed.

7.1: Licensing

Governments license activities (and forbid unlicensed ones) for a variety of reasons. Not infrequently, the habit of licensing remains even when the original reason is forgotten. For example, radios were licensed in Britain originally because the government feared that the new medium would be used for spying, but the habit of licensing persisted long after it had become apparent that it was no defence against espionage at all. In many countries special licensing of activities is required on the Sabbath or Holy Day, even though the country may no longer predominately be of any one religion.

There are four major ways in which arts events can be subject to licensing control. First, the government may, under one guise or another, license the *audience* to attend the event or license the individual to enjoy the art in private. Second, it may choose to have

a licensing system for all *venues* and public places in which people gather for arts events. Third, it may choose to license the *art work* itself, and to render unlicensed work illegal. Finally a state may choose to adopt a system of licensing the *artist*, so that people who are not directly or indirectly licensed to work as artists may not work as such in any professional or paid capacity. When the distinction is made in these terms, the reader may be surprised to observe that even countries which pride themselves on their benevolent and supportive approach to the arts nevertheless will often adopt all four positions, and license audience members, venues, art works and artists, with varying degrees of severity.

It is important to observe here that a sophisticated licensing system does away with the need for a seperate system of state censorship. If the granting of a television franchise, or a licence to run a night club, a cinema or community centre is dependent upon keeping on the right side of the state officials who grant the licences, then an effective self-censorship will generally operate. It is noticeable for instance that in the British theatre, since censorship was abolished in the mid-sixties, there has in general been less that is daring, less that is critical of the *status quo*, and much less that is shocking for the authorities. Nonconformity may mean that the theatre licence could be revoked, state subsidy removed, and a degree of professional status withdrawn from the transgressors. A recent argument, for example, at the once-daring and provocative Greenwich Theatre in London has led to the sacking of the Director and the resignation of two Board Members, as the theatre turns nervously to a self-imposed policy of theatrical caution. Some years ago the theatre staged the premiere of the acclaimed homosexual drama *Another Country*; in the midst of the recent turmoil a board member who is remaining is quoted as saying, 'If it came up now, I'd rather not have the risk and not have the money.'

7.1a: Licensing the Audience. It is common in advanced countries to license some audiences by age. For example, some films may not be shown to persons under eighteen years of age. (It is, by the by, noticeable that licensing by age usually follows on the heels of the creation of a state education system.) Other prohibitions may however be imposed by governments, including, in South Africa,

the licensing of some events solely for persons of one particular colour of skin.

7.1b: Licensing the Venue. Almost all countries have a system of licensing venues, ostensibly for reasons of public safety and public order, although on occasion the withdrawal of a licence may be clearly political. It has for example in Britain become very much harder to hold a legitimate public demonstration; the licensing system has become much more astringent and the cost (of paying for the policing) much greater. The 1988 Notting Hill Carnival's policing costs were more than two million pounds.

7.1c: Licensing the Art Work. Practice in licensing the art work for public performance varies widely from art form to art form and from country to country. Most technologically advanced countries license films for public showing and have a degree of licensing control over radio, television and cable television. Few countries now demand that play scripts be licensed in advance of performance — though some, Hong Kong for example, still do. On the other side of the coin, however, few countries do not have means of withdrawing books from the general public gaze when they so desire. This may be achieved by forbidding a publisher to put a book on sale (as the attempt was made to stop Penguin Books from publishing D.H. Lawrence's *Lady Chatterley's Lover*), by prosecuting booksellers who try to defy that ruling, or by so fashioning the licensing of a bookshop or library that a self-censorship once more operates. In the last years of the left-wing Greater London Council, libraries and schools under the G.L.C.'s direct and indirect jurisdiction removed sexist and racist material from the public eye with a fervour that sometimes outstripped the political zeal of the authorities.

7.1d: Licensing the Professional Artist. Again, most countries, however dedicated they may seem to be to the free market, impose this kind of control. It is not for example possible to act on Broadway unless you are a member of the U.S. actors' trade union, Variety. Nor is it possible to do so, if you come from overseas, unless you are also approved according to the systems of exchange for actors and companies from overseas. In this respect New York

ressembles Moscow, where anyone wishing to work as a professional actor must also be a member of the state- approved union. Most countries have similar, though somewhat less rigid, constraints upon professional musicians. Some (the Communist countries, in general) also have rigid constraints upon who may and may not practise as a professional writer or a professional artist.

A growing twentieth century phenomenon is the artist in exile; the writer, painter, dancer or director who works outside his or her own country, because the artistic climate for them in their home seems wrong. Exiles from totalitarian regimes in general seem to retain a strong affinity with the traditional values of their homeland, and often − as has recently happened with the dancer Nureyev's return to the Soviet Union, and the film director Polanski's return to Poland − will affect a reconciliation with the occupying regime. Exiles from democracies, where the control over artists is less harsh, and the freedoms to create more apparent, seem to suffer a deeper disenchantment. British exiles − Peter Brook, Graham Greene, John Neville, David Hockney, Dudley Moore seem in their different ways to recoil from a subtle, unseen but pervasive control which sometimes seems to them more insidious and more powerful than the more obvious rigours of totalitarianism. It is, in Hockney's memorable term, a habit of *Nannying*.

7.2: Taxation

In general, three types of taxation crucially affect the operation of arts markets. First is the form of taxation upon artists; second is the personal taxation levied on the public at large; third is the taxation upon the various services offered by the arts organisations, including, most crucially, the service of selling tickets. These three systems amount to a formidable means of government control over the arts, and it is a control with two further instruments of refinement. First, governments may choose to intervene in arts markets by making certain crucial exceptions to tax liability, may choose, for example, to cut taxation of admission to opera but not to circuses. Second, governments may choose to to circumscribe the ways in which money gained by local or national government may be spent. In Britain for example, monies raised in local taxes

by local government may not be spent on direct promotion of the performing arts — although grants may be given to separately constituted groups.

7.2a: Taxation on Artists. In general, artists are taxed as are other mortals, which causes them considerable difficulty. The reason for this is that many artists do not earn wages at the same steady rate that bank managers or tax inspectors might do; their earnings fluctuate wildly, good years following bad. Also many artists have earnings in kind, and to decide what the returns to the tax authorities should be usually requires the services of an expert accountant. It is obviously difficult to decide what should be an allowable expense in the case of a portrait painter, for example, or an itinerant film producer trying to assemble the backing for a new film. A third difficulty is the internationalism of art; many performing artists in particular are paid for overseas work, which is taxed in the country in which it is performed, and then subjected to further scrutiny by the authorities in the country of residence, who will sometimes add their own bill, some time after the event, to bring payment into line with the resident country's rates.

Artists living 'in exile' will often cite their home country's tax laws as being a major cause of their defection. Aware that such habits bring no particular benefit to their country of origin, governments will sometimes reach understandings with famous artists that if they do return to their home country then, for a period at least, they will not be prosecuted for outstanding tax. Some countries have adopted more drastic remedies still. Ireland does not ask its residential writers to pay tax at all (a fact which has helped many U.K. writers as well as Irish ones; a number of overseas writers have chosen to make their homes there). In Britain it was mooted before the 1988 Budget that the Chancellor's intention to drop the top rate of tax (in the event, dramatically, to 40%) was in part to attract back to Britain the large numbers of actors, writers, composers and artists who have chosen to live abroad.

7.2b: Personal Taxation. In a 1986 public lecture, the Chairman of the British Arts Council, Sir William Rees-Mogg, said that he wasn't sure that he didn't prefer a decrease in direct personal

taxation to an increase in state subsidies. This sounds an attractive enough notion, but unfortunately increases in personal spending power, of the kind a decrease in personal taxation brings, do not lead to additional spending in the arts. In many capitalist countries, including Britain, Canada and the U.S., spending on travel, eating and drinking, activity holidays, home improvements and home entertainments has continuously grown at a far faster rate than expenditure on buying theatre tickets, concert-going, visiting galleries and the purchase of books.

7.2c: Taxation on Services. This may take the form of a tax imposed by central government (as in most European countries) or a tax imposed by a city or region (as in New York). It most sharply affects arts organisations when it is imposed as a tax upon the price of admission to arts events — when the provision of an artistic experience is seen by government as a taxable service. Britain has a long history of one such specific tax; the Entertainments Tax was imposed in 1916 to raise funds for the war effort, with assurances that it would only last for the duration. In the event it lasted for half a century, and was a continuous cause of dissention. For example when, in 1924, the Entertainments Tax was removed on all seats up to 6d. in price and lessened on all those costing up to 1s 3d., it was claimed by indignant theatre managers that this gave an unfair advantage to the cinemas which had a far higher proportion of their seats at lower prices. As late as the mid-nineteen fifties there was another fracas when the Arts Council (whose clients were registered as charitable organisations and hence did not pay the Entertainments Tax) refused to join a campaign for the abolition of the Entertainments Tax on all theatre seats.

7.3: Education and Training Systems
One of the virtues of education is that it provides a means of enjoying the arts for people who would not learn to enjoy such things from their families or from their peer groups. It is possible to describe a state education system in such approving terms, and to describe 'education' as if it is automatically a benevolent process, self-evidently positive and enlightening in nature. It is even possible to assert that 'the arts' must work with 'education' as if it were

obvious what this means, and obvious that it would somehow be an enlightened thing to do.

In truth, beyond the kinds of platitudes which say that all art involves the onlooker in some kind of self-education process, or that all educational processes may bring the student nearer to understanding some kind of art, there is not much that can nowadays be said sensibly about two such imprecise and overused notions as 'education' and 'art'. When policies are propounded which want to link the two, they are often of an alarming vacuity, and sometimes may hide a horrible urge to bully and to control.

Both aspects are to be clearly seen in the British Arts Council's decade-long flirtation with an 'education policy'. It decided that it would be right to develop such a 'policy' in the late seventies, and produced a series of rambling discussion papers which showed, if nothing else, that the Arts Council authors were indeed more ignorant than they should have been of the ways drama, music and art had been taught in post-war schools. Even at that early stage, however, it was apparent that what the Arts Council had in mind was using the education system to enlarge audiences for the subsidised arts - education was seen as a kind of marketing tool, and as a means of promoting the social purposes which the Council was adopting in place of its former artistic ones. Significantly, 'education' was used as a term interchangeably with 'training'. In those early documents there were many clear indications that the British Arts Council saw 'education' as being essentially a training to understand the subsidised arts, and a training in the currently fashionable social attitudes towards the modish minority arts.

By 1983 the formulations had become more sophisticated, but in the widely circulated (free) document *The Arts Council and Education: A Policy Statement* it announced that it was clarifying its beliefs and principles. It clearly states the now widely accepted view that 'the arts' in the modern bureaucratic definition are a small part of the national culture, and that it is indeed possible to have a culture which does not include subsidised art:

> The arts may be more readily available but there are other barriers which prevent them becoming accessible. For many people the arts are a closed book because they have been influenced (by their social class, education, or culture) to believe that the arts are 'not for

them'. There is an attitudinal barrier to access. Even beyond this the arts are still not truly accessible if they are not understood.

However this kind of guff contains the unspoken but immovable assumptions that the cultures, the social classes and indeed the education systems which do not provide audiences for the subsidised arts, and instil the right attitude towards the subsidised arts (that is what is meant by 'the arts' here — those things the Arts Council subsidises) are all inferior, and worthless. It is inconceivable that a properly educated person might choose to find enrichment and value in those realms which the Arts Council does not control. People may not *choose* to find significance elsewhere; they are obviously, through being born in the wrong class, having the wrong culture or having had the wrong sort of education, simply running up against *an attitudinal barrier to access*.

There are a number of key words in contemporary arts policy-making which tend to blur the coarse and despotic ambition some cultural barons have. One such, which we noticed above, is 'training', which is invariably used by arts bureaucrats in the slightly demeaning way circus proprietors use it. Another word to be carefully watched, as we shall see later in the book, is 'development'. But neither of these is quite so dangerous a term as 'access'. It blurs a number of terms — eligibility, suitability, availability among them — and hence is a useful word for avoiding detailed discussion of the many different things involved in the arts finding their audience. It makes 'available' mean 'on sale', and 'accessible' mean 'motivated to buy'. Apparently 'access' is made possible by the removal of one attitudinal barrier — but a barrier which may be compounded of everything you have learned at home, at school and within your culture! (Then of course you have to understand the arts, but apparently that is a secondary matter.) The crucial thing is getting the *attitude* right. (It is inconceivable that someone should actually understand the art perfectly well but still, for good critical reason, not wish to display the right attitude.) 'Access' is thus a term of the utmost vulgarity, hiding an arrogant belief that the Arts Council knows the reasons why people don't wish to make the subsidised arts central to their lives, and implying that 'access' is so important that they must suffer an attitudinal change which runs counter to their families, education and culture.

Few dictatorships would assert such a belief so coarsely, and in a democracy which used to believe that questions of value are best settled by critical debate and mutual accommodation, such arrogance can only display a profound ignorance in the writers of what they think they are talking about.

Almost at once, in the same publication, the authors do display their ignorance quite blatantly. First, they make the mistake of including a section called 'What Do We Mean by Education?' which bears the unmistakeable imprint of bureaucratic minds at the end of their tethers:

> We are concerned with three aspects of education. First, education as a long-term process, involving many different and complementary types of learning, through which each person is helped to develop his / her individuality and ability to operate in, and relate to, society.
>
> Second, the education system itself, to further, higher and continuing adult education.
>
> Third, with reference to our charter, education is seen as encompassing a wide variety of approaches by arts, educational and other organisations and by individuals, designed to lead to a general valuing of the arts and a wish to become involved in them, and to awareness of the meaning of particular works of art or creative acts.

This is for the most part either platitudinous or gibberish, the kind of thing would-be entrants to B.Ed. courses might frenziedly write in an entrance examination, but when it does mean anything concrete at all, the arrogance and bullying tone reappear. Education is seen as encompassing a wide variety of approaches - all well and good. But then it narrows alarmingly. These approaches must be 'designed to lead to a general valuing of the (subsidised) arts and a wish to become involved in them.' Those great sections of arts education which do not lead students to have pro-Arts Council attitudes, and which might even lead to a well-formed rejection of some of the subsidised arts in favour of other activities within the common culture, are now to be denigrated. The authors are very clear about the limits to which a person should be free to develop his / her society. Education gives 'access', and that means access to the subsidised arts.

One could hardly have a clearer indication of how the state education system, which many would see as an instrument for developing in the individual the right to make informed choices, can become at least in the minds of some policy-makers, a very much blunter instrument, a tool to force state-approved attitudes towards art upon as many pupils as possible. Such attitudes are very clear in totalitarian regimes, where both education system and arts provision are totally controlled by government, but it may not be immediately apparent that it is possible (as with this British example) to see such policies propounded in democracies which pride themselves upon their multi-faceted education systems and their long traditions of open critical debate.

When a society is moving towards using the education system as a means of direct cultural control, it is likely that the following trends will become apparent: (i) There will be moves towards more centralised, government-controlled curricula for all subjects; (ii) Institutions and teachers will be regularly 'assessed' by central government authorities, and will be respectively 'developed' or 'retrained' when they fail to meet the governmental criteria; (iii) Funding and resources will be made conditional upon satisfying the government criteria; (iv) bodies which may choose to ally themselves with the education service (such as the Arts Council) will themselves be assessed and 'developed' according to central government criteria. When each of these steps is in train, it will usually be found that a common language, within which the government can exercise the required control, has developed. This is so in Britain, where arts and education organisations now accept that they will be 'assessed', according to the ways in which they have exhibited their 'enterprise', 'maximised their resources' and 'met their targets'. They will now report on whether they have, 'improved access' for the centrally-targeted groups, through efficient 'marketing'. In all of this, government becomes more intrusive. The new imposed language sets the agenda, and the decisions of 'assessment' are taken by those same agenda-setters. The control government thus comes to enjoy through the state education system means that a separate system of censorship is hardly required at all.

7.4: Censorship

Censorship (which forbids the presentation of any art not fully licensed by the State and which backs up its edicts with strong penalties) becomes, as we have seen, less in evidence when the state licensing system, state education system and state taxation system provide governments with sufficient means of control. It may however continue to exist as a complementary government activity, even when the state has full powers in those three fields.

In some ways it is rather more sinister when it disappears as a separate and accountable function of government, and when government attitudes to freedom of speech, dissent, sexual licence, anti-religious sentiment, political opposition, racism and much else only become apparent through actions (in shutting schools, raiding the state television or radio service, refusing licences, etc.). These actions may be coherent - it is not for example difficult to discern the philosophies of South Africa's Premier P.W. Botha in his actions — or they may be rather more confused. Britain's present government has for example frequently signalled its dislike of sex shows — there have been several moves against pornography. Yet, during the Falklands campaign, a government plane flew out copies of soft-porn magazines to the troops, given by Paul Raymond, but 'postage' paid by that same government.

At such moments it is useful to remind ourselves that most attempts to formulate the objects of censorship logically and coherently look ridiculous. To try to list precisely which things will at any one time be considered blasphemous, pornographic, seditious or otherwise undesirable almost invariably means that you find yourself excluding many of the world's great books, plays, pictures and films. To say that an exception will always be made for artistic quality is to beg another question, for 'artistic quality' is a variable notion, and one governments cannot be trusted with. Much that is now considered of high artistic quality was once considered obscene or wicked. In the early years of the century, for example, most reasonable and well-educated Englishmen would have scoffed at the idea that *Oedipus Rex*, then banned from performance, was of high artistic worth.

Governments may therefore prefer imprecision. They can then react with a degree of political pragmatism and, less commendably, can assuage their own dark fears, without seeming ridiculous by

having to confess them openly. Fears of youth can be exorcised by banning pop concerts, closing discos, restricting admission to football matches by young people — all in the name of public order. Fears of political dissent can be overcome by weighting the grant-award system against 'minority', 'unpopular' and non-profitable organisations, and by taking the most extreme legal action against one or two genuinely culpable offenders, so that publishers and television bosses and newspaper proprietors feel that it is hardly worth voicing other, more innocent, forms of dissent. In this way, as the overt systems of censorship disappear, paradoxically, overall censorship can become more powerful. Licensing systems, taxation and the state education system can all become partial instruments for state censorship and control, and so, even as it proclaims that it stands for the freedom of the artist, can an Arts Council.

8: Arm's Length From What?

It would of course be ridiculous to claim that Arts Ministries, Arts Councils and all other governmental and neo-governmental bodies ostensibly set up in support of the arts are simply disguised agents of government oppression. They can certainly become so, willingly or otherwise, but it does not have to be the case. In Britain for example, the Arts Council has not always seen itself simply as, in Sir William Rees-Mogg's words, 'the government's means of funding the arts'. It has indeed in past times been proud of its independence from government, taking decisions about the arts without being influenced by party politicians. In their turn, clients of the British Arts Council used to be encouraged to feel that they were independent of direct influence, either from the Council or from local politicians. This convention was supposed to be a proud British invention, and had a name. It was called 'The Arm's Length Principle'.

It was not a principle in any of the normally accepted senses. It was certainly not a legal principle. The Arts Council's charter does not legally guarantee it any kind of immunity, any more than parliamentary law says that the British Arts Council has to be given money each year. Nor is it a scientific principle. If anything it is a principle of etiquette, a convention which has roots in earlier systems. In the First World War for example, government gave money to the War Office Cinematograph Board, which sponsored the making of wartime films. Government did not however interfere at all in the choosing of scripts or the shooting of the films; indeed the first beneficiary of the Board was D.W. Griffiths, who made a film critical of government. The 'principle' was further established with the creation of the BBC. When that body was effectively taken over by the state, on 1st January 1927, it did not come directly under politicians' control, but was instead run by a Board of Governors whose independence from government interference was

a model to those involved in the formation of the British Council, and, later, the Arts Council, Design Council and Crafts Council.

The 'principle', of non-interference by government, was promulgated by Arts Councils in English-speaking countries for thirty years and more after the war. Arts bureaucrats announced, as if they were making a theological judgement of the most luminous kind, that they 'believed in it'. Others asserted, as if it were a precise legal or political axiom, that other countries would be the better for adopting it. Lord Goodman for example opined that South Africa would be a much better country if it had an Arts Council and adopted 'The Arm's Length Principle'. A 1976 report on the arts, commissioned by the Gulbenkian Foundation, and sitting under the chairmanship of Lord Redcliffe Maud, championed the 'principle' as a bulwark of the system, and even a kind of guarantee of the freedom of the artist.

Thus, for decades, a polite convention, depending upon the free agreement of all parties to give it substance, was aggrandised in significance. It did not matter that, in spite of the convention, politicians plainly *did* interfere with artists' freedom; those were occasional aberrations which made 'the principle' more important. Nor did it matter that some artists in all countries saw their Arts Councils' own activities as being highly political, and grossly interfering; at least such interventions were not from that most vulgar of all sources, the elected politician. The political etiquette, which was comfortably maintained when public money was in plentiful supply, was in the event, however, no defence against the political and economical fervours which led governments of all hues in the late seventies and the eighties to cut back on public spending and to demand what they termed 'greater accountability'. Government control of arts markets became, in Britain, Canada, Australia, U.S. and other countries much more direct. In their turn Arts Councils overtly mirrored the fiscal and managerial philosophies of their governments, and became in their turn more interventionist. Against this 'The Arm's Length Principle' was no defence because when people chose to act in that way, it had no substance as a barrier. Indeed, so vaguely had it been formulated and understood, that from time to time governments even claimed that 'the principle' still existed, and that although they were being

more interventionist in terms of management, or fiscal control, the essential 'freedom of the artist' remained.

That 'freedom' was revealed as no more than a piety. The interventions by government in the eighties seemed to be of a much more direct, and even brutal kind. In the United States, in the early years of the Reagan Administration, government officials intervened directly to change the majority of the top personnel in the National Endowment for the Arts, an action which seemed to involve what many people saw as a direct attack on the homosexuals in top jobs. That process was echoed elsewhere, although top managements of Arts Councils were changed for other reasons. Canada Council suffered considerable trauma until its director, whose views were not to the liking of the new-style government, departed, and there followed a long period of acrimonious public debate about the succession, and about the Council's purposes. In Britain the incoming Conservative government, with rather more decorum, proceeded to rid the Arts Council of its cultivated liberals, and to replace them with people who saw the arts essentially as a business. Following the final departure of Sir Roy Shaw, the role of Secretary General was diminished in importance, and the role of Chairman made much more powerful, and occupied by a High Tory, Sir William Rees-Mogg. The newly-peopled Council lost no time in announcing how it saw the arts:

This small but successful part of Great Britain Inc.
(Arts Council Annual Report 40)

The capitulation to government ideology was less pronounced in Canada, and far less pronounced in Australia. None of the publications emanating from Australia Council in Sydney (or from the State Arts Councils) reached that level of cringing banality. For all its measured decorum, the British government had achieved an ideological take-over of the Arts Council which seemed to be absolute. The publications of the Council were now couched in coarse ultilitarian terms; the arts had become an 'industry', art had to be measured and appraised essentially by its economic performance, and although creativity, talent and genius were all now set at nothing, arts organisations could still find government

approval by demonstrating their *commercial enterprise*, accountable to *Great Britain Inc.*

The key shift in meaning here is in the term 'accountability'. In the sense that they were obliged to give some public account of their actions, and forced by law to publish financial accounts, Arts Councils in the English-speaking world have always been accountable to governments, and the general public. Councils have always published annual reports, including considered deliberations upon their philosophic notions and general purposes, and detailed audited accounts of what they have done with their monies allocated to them by government. However, 'accountable' has now shifted its meaning. It now means 'responsible to governments', rather than 'responsible for the allocation of government money'. The responsibility is now primarily political, rather than critical or financial. The 1987 *Arts Council Report* (Number 42) in Britain gave the clearest evidence of this. It was almost wholly dedicated to describing facets of its own managerial organisation. Such few art works as were mentioned were praised for the structure of their funding - public statues for example were not to be praised simply because they happened to be beautiful, provoking or elegant, but because their funding had been politically impeccable - industry, local government and Arts Councils chipping in cash in the right proportions. For the first time ever, the Annual Report contained no financial accounts, 'Accountability' was now a quite different animal.

Government take-overs of Arts Councils in the English-speaking world have been achieved in part by the simple changing of key personnel. But another, much more insidious, means has been adopted to gain control. That has been to change the language in which government, Arts Councils and clients address each other. The key shift has been to describe the arts no longer in their traditional language which includes aesthetic judgement, private satisfactions and spiritual benefit, but as a purely commercial entity, to be justified by its economic benefit. Criticism, arts education and cost benefit analysis have in their different realms been replaced by Economic Experts, Management Training and Market Reportage. Many government-accountable publications about the arts retain a top dressing of platitudes about 'excellence', 'quality of life', 'participation', 'multi- cultural education', and other

fine-sounding phrases, but the heart of the presentation is almost always a crude and imprecise business account, in which arts administration and indeed the processes of arts creation are described as so much grocery, and art is product and its meaning so much *data*.

Arts bureaucrats - in this instance those who one way and another administer the public funds which are ostensibly set aside to support the arts - have, sometimes willingly and sometimes not, come to adopt this kind of managerial language over the last ten years or so on a surprisingly wide scale. Art depends, not on genius, but *marketing* for its effect. Arts markets do not depend on people voluntarily paying, but on a much more political notion, getting *funding*. The world of business - stock market speculation, property values, insurance and so on - is the *real world*. Beethoven, Dante and Shakespeare are unreal. Arts bureaucrats must now set themselves management objectives and be *appraised*, aiming of course always to achieve *efficency* in their use of physical and financial *resources*, and aiming to achieve *optimim production levels*. Once this kind of language is adopted, then there is little need to agonise over any precise formulation of government intentions towards the arts. For the arts bureaucrats the language *is* the policy.

8.1: The Bureaucrats and the Artist

It may of course be that the capitulation of the arts bureaucracy, its surrender of its own critical language, and its modern habit of talking to governments dedicated to cutting back state spending 'in the only language they understand', does not have any directly adverse effect upon the artist. It is after all perfectly possible to imagine a government bureaucracy discussing a profession - soldiery, medicine or university teaching, say — in the most quantative and mercenary terms without having a necessarily adverse effect upon its members' ethics or their work. The professionals would retain their own language, argue for support on their own terms and for their own needs, and successfully defend their own professional integrity against encroachments by government by refusing to discuss their professional practices in alien terms.

Plainly, whatever arguments there may be for forcing arts bureaucrats to adopt the language of merchants to describe what they do, real *art* can never be described and appraised in such a language. There is no such thing as an optimum production level in art. What is there to say about artists with a prodigious output - Barbara Cartland, for example, who averages more than twenty novels a year - as against those with a very slight output, such as E.M. Forster? That information only tells us that Barbara Cartland publishes a very great deal more than Mr Forster did; it does not tell us whether either has achieved any kind of optimum. Should Forster have published more? Should Barbara Cartland have been persuaded to publish less? Should there have been a *merger*? We may have views about it, but our views do not derive simply from their level of production. And we can deduce nothing from this which allows us to suggest optimum levels of output to other aspiring novelists.

Nor is there any notion of efficiency which can take us very far in describing the arts. Reports on, say, the production of opera may point to apparent wastefulness in staging; scenery being repainted expensively after a dress rehearsal, costumes being scrapped too late, and other things which, in retrospect, do seem wasteful. Yet this does not mean that it will be possible on a subsequent occasion to plan everything down to the finest detail before production work begins, and to avoid change. One may as well deny the painter the right to repaint a part of a picture, insisting that every square millimetre should have been accurately planned in advance to avoid the wastage of paint. If the painter is allowed to change nothing, it will be shoddy work, painted by a production process rather than a creative one. Similarly, if alien notions of efficiency are imposed upon the opera designer, then the work will either not appear, or be awkward and inert, if the budget has not allowed of adaptation and change during a creative rehearsal period. In Britain Opera North were forced to confront this problem in the Spring of 1988, when managerial and budgetary restraints were strictly imposed, in advance, upon the company's planned production of *Fidelio*. Designer Stefanos Lazaridis then resigned, saying that 'the conception devised' was proving impossible to realise 'within the budgetary constraints'. Managerial notions of efficiency are never straightforwardly applicable to the processes of artistic creation.

Nor can ordinary commercial marketing practices be applied wholesale to arts markets. Marketing experts are used to analysing the marketing of goods and services, and indeed quite often announce that everything is either a 'good' or a 'service'. However, in spite of the wish of some right wingers to describe the arts as being simply goods, and the desire of some left wingers to see the arts as public services, the arts are in nature neither wholly one thing nor the other. In assembling a Hockney retrospective, or in staging *Billy Budd*, say, there will be times when the art works and what is being done will be discussed as a public service - consideration will be given to the length of the time the work will be available for the public pleasure, and such matters as fashioning easier admission for unprivileged groups will be discussed - and times when they will be regarded as goods - when the overall budget, admission prices or associated merchandising is on the agenda - but most of the time the directors of artistic enterprises think of what they are doing as something quite different from simply marketing a product, or making a service available.

In this third realm the arts have primacy. The paintings themselves dictate the kind of space they must occupy, how they must be lit and how seen. The opera demands certain musicians, certain operatic and dramatic skills from the players, and a certain kind of venue. They demand conventions of behaviour from the public - unlike goods which once purchased may be used in any way the purchaser chooses, and services which adapt to meet the idiosyncratic wants or needs of the public. Neither wants nor needs for the arts can be reliably measured in advance of the public showing. Market surveys can reliably be done which forecast how well a new chocolate bar will sell, by giving a cross section of people a nibble of the confection, and asking them which label they prefer. One cannot open a suitcase and play a snatch of a new opera and from the public's reaction either forecast what the demand will be or how well it will be received. Each art work is to a degree unique, and its special composition pleases or displeases the public in ways far more complex than those of a chocolate bar or a chimney sweep; unlike goods or services, art contains within its individual form the means by which it may reach its public. It cannot be simply repackaged in a wrapping which panders to supposed market needs. One of the few editions of *Oliver Twist* which has ever failed

to sell was a paperback version which had a lurid cover which played down the author's name and title, but featured a hugely bosomed woman improbably dressed in Victorian costume and a lascivious youth peering down her frontage with the vivid headline 'The Boy Who Wanted More!' Presumably those people who might enjoy reading the novel were repelled by the cover, and those attracted by the cover were in turn repelled after they had flicked through a few pages at the newstands.

The question therefore in part comes down to whether the businessmen's language in which government and arts bureaucrats may choose to converse - the language of optimum production, efficiency, marketing and appraisal of management - actually reaches so far down the funding system that it radically affects the creative processes of artists and distorts the way they might otherwise reach their public. In many countries one can see the battle joined. Government and arts councils setting up application forms for state support which ask less about the art than about the managerial and political organisation of the group, or allocating funds primarily to those who have followed central government 'guidelines' on arts programmes and on organisation; the intentions of central governments are clear enough. Equally one notes the resistance; the protests, the resignations, the artists who can no longer live and work in their own countries, the more or less strident tone of opposition to all of this from real critics and real artists. It is, literally, a battle of words; the crude language of market place materialism against the subtler, allusive, ironic and value-drenched language which artists use amongst themselves.

The weakness in the case of governments, who choose to see the arts as a business like any other lies in the temptation to argue for the arts on the basis of their supposed *effects* - in reviving inner cities, attracting tourists, reducing crime or stimulating the economy. Such discussions seem more tangible, but they play into ignorant hands by suggesting that the arts *must* make their case solely on grounds of quantifiable and measurable benefits they supposedly bring. But the central case for the arts is not what social and economic effects they may have, but what they *are*. That is their reality.

There is no likelihood that governments will ever prove to their own or others' satifaction, that their view of 'the arts as business'

has any final reality. Earlier attempts to impose the court culture universally, or to refine all artistic expression according to the Puritan ethic had some effect, but artists and their audiences accomodated to the immediate political pressures without yielding the substance of their art, and one may expect the same to happen with the present wave of mercantile pressures. Just as Cromwell's puritanism was too simple to cope with the myriad ways in which forbidden artists still found their voices in the mid-seventeenth century, so are arts policies which hold that the market place is sovereign likely to find that artists are subtler than legislators.

It is not even obvious that artists find themselves more put upon when directly elected politicians more plainly intervene in the arts bureaucracy. Although the old 'Arm's Length Principle' supposedly protected them from elected politicians, it did not always protect them from the arts bureaucrats. To many, the language of the old-style British Arts Council was as offensive in its way as is the language of the present body, its gentlemanly behind-the- scenes politicising no less dangerous than the brasher and more open interventionism of the contemporary one. To some it always seemed that the Arm's Length Principle gave freedom only to the arts bureaucrats - they were free of direct government interference, and free to behave as they wished towards their clients. All that has happened, in the view of some artists, as governments have become more closely allied with their instruments of grant aiding, is that the language of state patronage has become coarser, grant applications have to be written in a different kind of language and intervention is less circuitous. To other artists, however, the new and insistent commercialism of government arts bureaucracies is of a nature more coarse and destructive than any other 'policy' adopted in an advanced country since the Second World War.

9: Politics and Planning

Michael Trend has recently pointed up the interesting history of the word 'policy':

> If you look it up in the largest dictionary of quotations you find this simple message - 'Policy; see Cunning'. Under Cunning it adds 'see also Deceit and Hyprocrisy'. What it shows is the older meaning of the word - a policy: a device, expedient, stratagem or trick. Now, however, politicians have chosen to make the word respectable. Policy is thought to be a good thing and parties must have lots of it.
>
> *(The Spectator* 23.4.88)

As happens with words that become respectable, 'policy' has also tended to become a catch-all phrase, with a spread of different meanings that run into each other. Some 'arts policies' for example are simple descriptions of the past; the government or party propounding the policy will describe its practices and mention some of its successes and say in effect 'that is the sort of thing we do'. Other 'policies' consist of a recitation of high-minded ideals - belief in the freedom of the artist, the right of the customer to have a range of choice, the inadvisability of politicians interfering with arts bureaucrats and so on - axioms which, one is bound to say, often bear little relationship to the concrete procedures and controls proposed in the same document.

To take one example from many, the Australian Liberal Party offered an 'arts policy' for the 1987 election that had the following as its main aims:

* To maintain and develop cultural activity and diversity throughout Australia

* To ensure that the Arts are accessible to the broadest range of geographic and income groups

* To recognise the importance of both private and public sector patronage and to create a climate encouraging to private sector support

* To ensure that support is given to both traditional and innovative activity

* To facilitate the widest possible participation in the Arts by all sectors of the Australian community

This is a series of aims which would have been broadly acceptible to the full citizens of fifth century B.C. Athens. To achieve them would require a massive and revolutionary alteration in many aspects of Australian life - vast changes in the education system, massive new investment in road, rail and air links between all kinds of communities in the outback as well as in the fashionable cities, wholesale changes in the taxation system, constitutional changes establishing participation in the arts by people of all cultures as a right rather than an occasional privilege, and a fundamental redefinition of 'art' itself. In other words every possible governmental power would have to be harnessed to carry through such a fundamental change in the nature of Australian life.

And yet how did the Liberal Party propose to satisfy these grand aims? i) By altering the role of the Australian Arts Council so that it became more of an advisory body, and ii) by taking over the funding of major arts organisations within government itself. It is as if massive changes were being proposed in a government's defence policy and the only means suggested to bring them about were that the army's paymasters should alter their invoicing system! The Liberal Party may of course have had clear notions as to how, if it gained power, it actually would bring about the results it desired, but it did not feel that an 'arts policy' needed to mention them. It was enough to offer one or two suggestions about changes of emphasis within the funding system, and to allow that to stand as a metaphor for the range of practices which (presumably) would be adopted.

This brings us to a third meaning of 'policy' which politicians habitually use. It derives from a common usage within government bureaucracy, of defining 'policy' in effect as 'putting into practice'. This meaning is most obviously associated with the Policy Unit at 10 Downing Street, which does not theoretically formulate new policies, but rather seeks to put existing policies of the Prime Minister into practice. By this definition, there is no need to be very precise about aims - sufficient to offer the bland unexceptionable aims of the party or government in question. Having an 'arts policy' then will simply mean that every decision taken by government bodies about the arts will be taken in the light of prevailing government thinking, rather than in the light of the cultural traditions of the country or the inherent qualities of the art form under discussion. Parties which develop arts policies in the light of this kind of belief will often put in some kind of metaphorical guarantee of the artists' continued independence from government - 'the maintenance of the peer group assessment ideal' or the desirability of continuing 'the arm's length principle' - but in practice such assurances will have no substance. The bland, and unattainable, ideals, and the obvious inadequacy of the means proposed in print for attaining them, indicate that what is really being proposed is a change in governmental *practice* - the 'policy' means that the arts, where possible, are being seen as an instrument for the promotion of a particular political view.

A fourth (and not altogether despicable) kind of policy is the kind which seeks to achieve no more than a change in definition. In the arts, where most important terms are judgemental, how we speak of them is obviously of prime importance. The arts world does not have output figures, notions of production line efficiency, or simple notions of demand and supply which enable us to come to any kind of final judgement. No mechanism - except the persuasive terminology we choose to adopt - enables us finally to say whether a civilisation which produces one fine composer is 'better' than one which produces five less outstanding ones. Therefore it makes perfect sense to say that the policy *is* the language. It is also true that a positive critique of the prevailing language may effectively be a proposal of a different and better policy. The imposition of political jargon may herald a worse one.

A recent, and unfortunately typical, publication of the British Arts Council affords us innumerable examples of this kind of jargonised 'policy-making'. The publication is called *An Urban Renaissance*, and it is brought out to show how 'the arts' will fit in to the Tory party's professed wish to improve the decaying inner cities. It begins with a highly slanted account of the reasons for inner city decay in Britain (all the fault of the socialist planners of the sixties who built ugly tower blocks - nothing to do with unemployment, with growing differences between rich and poor, the breakdown of many social, educational and health services, or the near-collapse of inner city communication systems). It then goes on to announce that 'the arts' can, through the luminous leadership of the British Arts Council, put right these wrongs. And how? 'The arts' are somehow to be implanted in these depressed areas because 'They attract tourism and the jobs it brings.' And, in answer to any query about quite how these wrecked and insalubrious districts are going to gain the willing cooperation of their inhabitants in turning themselves into theme parks for the delight of rich overseas visitors, the rhetorical temperature of the document rises shrilly. A host of cant words (from the same dictionary that gives us 'enterprise' and 'development', 'access' and 'targeted') cascades towards us in a jumble of mixed metaphors:

> The arts create a climate of optimism - the 'can do' attitude essential in developing the 'enterprise culture' this government hopes to bring to deprived areas. Inner city economic stagnation is a downward spiral. Failure breeds on failure, people lose confidence in their ability to succeed and consequently their will to try. The arts provide a means of breaking this spiral and helping people believe in themselves and their community again.

The first reaction to this kind of tosh is bound to be a slightly fazed incredulity. Downward spiralling stagnation is in itself hard enough to visualise. But what truth is there behind all these axioms, should we dare to question such violent assertiveness? Just *where* have the arts, the real arts fashioned by real artists, created a 'climate of optimism'? Did D.H. Lawrence pull his native Eastwood out of its own dark downward spiral? Did Virginia Woolf significantly regenerate the enterprise culture of Bloomsbury? Have Francis Bacon, Edward Bond, Michael Tippett, Geoffrey Hill, Lucian Freud,

or indeed any of the significant creative minds of our time actually sought to have, or had, the effect of instilling a simple 'can do' Tory mentality in their various constituencies? And if the Arts Council does not mean by 'the arts' the work of our best artists, what does it mean?

The answer might lie in the fact that the document is written in such an anxious sermonising style. It is less a document to be analysed, than a series of political signals about what, in its carrying out of general government policies, the Arts Council thinks it is expedient to proclaim as beliefs. As the authors are plainly careless about whether their assertions will bear any kind of testing against existing experience or knowledge, and are willing to make the kind of sweeping generalisations about human nature and human conduct which cannot be taken seriously at any level other than that of greetings card verse ('Failure breeds on failure' etc.), we must assume that this is being offered as a kind of political inspiration, rather than a basis for thought. What artists do, what people do, what the Arts Council does, may change very little. The document is opening the way for the use of a new kind of socio-economic terminology, capable of describing what has always happened in the new and more acceptable terminology of current Toryism. Where it exists, the association of an active artistic life and a degree of economic regeneration will be pointed up - Glasgow and Bradford's economic regeneration will be presented not as something which has happened at the same time as a resurgance of some kinds of artistic activity in those cities, but as if the arts have somehow caused it. The mental casts of their civic leaders' minds, which have led them both to invest wisely in forms of economic urban regeneration, and have led to a philanthropic desire to invest in good and worthwhile arts presentations, will be presented not as the cause of those revivals, but somehow the *results* of having 'the arts' in their cities. By this new terminology, it is you will recall the arts which promote the 'can do' attitude, not the enlightened 'can do' attitude of local politicians which helps to create an expanding context for arts promotion. And of course where massive investment in 'the arts' does *not* seem to do anything very much for a city wasteland, the whole subject is quietly dropped.

It is therefore quite reasonable that some arts policies should be based upon the need, as a first step, to question the existing vocabulary, and to replace it with terms which are less biased and which (perhaps) offer more possibility of real change. Unfortunately, however, most people engaged in the formulation of policies are forced to adopt the prevailing terminology of the central authority. Ministries and arts councils will demand that their subsidiary organisations, and their various clients, formulate policies within an imposed terminology, given sets of aims and objectives couched in the favoured judgemental terms. Deviation from this prescribed pattern - use of different terms, the setting of other 'priorities', questioning of the modish axioms of belief - will be described as anti-organisational behaviour, will be made to appear maverick and wilfully eccentric and if persisted in will be punished by withdrawal of money, or early retirement, or worse. The critical debate which must, as we continuously insist, be at the heart of an arts policy discussion, is thus denied, and replaced by a powerful linguistic control which sets the agenda for discussion and prejudges the flavour of all the answers.

This has been sadly apparent in the last years in Britain where the central Arts Council has asked its client Regional Arts Associations to work with their local government authorities to produce regional plans and strategies. In this exercise the format of the strategies has been given to the RAAs. So have the key terms in which the plans are to be formulated and (as necessary concomitant of this terminology) various axioms about the relationship between 'the arts' and economic growth, education, social relationships and individual spiritual developments are also 'given'. A timetable has been imposed and the resultant strategies are each presented (for validation against the prevailing central orthodoxy) to the central Arts Council.

What has happened can be readily guessed. The RAAs know perfectly well that the Arts Council does not collectively know anything very much about the area of Britain they happen to represent. (On a previous visit a midlands RAA was embarrassed to discover that a senior Arts Council official thought that the Black Country - a midlands industrial region - was the local name for the immigrant community). They know the members of the Council have little time to examine the differences between regions, still

less to immerse themselves in the complexities of becoming inward with, say, the cultures of the North East, the South West and the East Midlands simultaneously. They know that a terminology which suggests that all regions can be seen through the same set of lenses has been centrally imposed, and that they are preparing their 'strategies' not as a basis for action, but as a means of sufficiently impressing London's bureaucrats so that they will keep their jobs and their centrally-controlled income. The result is entirely predictable. With one or two exceptions, the 'strategies' make the regions of England - with differences nurtured over centuries - look pretty much like each other. As it is a bureaucratic exercise, the general solution to all 'problems' is to fund more bureaucratic activity, and in particular to formulate yet more reports, more plans, and more strategies. The cumulative effect of reading them is a depressing sense of a cowed subservience, as the plainly worried officials in the regions fall over themselves to assure London that they have thoroughly enjoyed the whole exercise and want to engage in ever more bureaucratic wordspinning.

One example will suffice. *The Regional Development Plan for the Arts in Licolnshire and Humberside* was published in December 1986, with a revised version in 1987. It is not in any of the respects mentioned above worse than most others, but it will give us a clear illustration of the tortured bureaucratic games that are involved in this kind of 'policy-making'. The 'development' plan was produced by the Regional Arts Association in conjunction with two County Councils, sixteen City, Borough and District Councils, the national Arts Council, Crafts Council, British Film Institute, and others, all of which the RAA calls its 'partners', implying that cooperation extends far beyond producing such documents.

The revised document has 188 pages in it, and the first impression the authors are anxious to give its readers is how very much everyone enjoyed being asked to produce it. Everyone has 'brought to the process enthusiasm and a desire to be involved'. This seems less surprising as the report develops its various themes, as it is plainly a report which intends both to trumpet forth the political axioms of the central Arts Council as if they are social

and economic truths, and intends also, above all else, to ally success in business with the growth of the arts bureaucracy:

> The arts also play an important part in creating the right climate for attracting business and industry to an area, thereby indirectly but in a very real way encouraging job creation. West Lindsey's District Council's commitment to capital and revenue support of the Arts Centre in Gainsborough was in part with a view to improving the facilities in the town which an incoming business would expect. Great Grimsby Borough Council's appointment of an Arts Development Officer was similarly designed to 'put Grimsby on the map' and the business world is already responding.

It is little wonder that the bureaucrats who complied the strategy had a desire to be involved if they are prompting the belief that any economic successes the good people of Gainsborough and Grimsby may enjoy in the future is a result of there being more arts officers in post. If the local citizens come to believe *that* then the arts bureaucrats can expect a comfortable life, basking in the warm glow of congratulation for economic events for which they have no responsibility. But the local citizens are more likely, should they ever read the report, to sense that there is nothing more than what the novelist George Eliot characterised as the exploration of an empty basin. This report is however not meant for them, but for the Londoners who prescribed its form; it reads like a frightened reassurance that the metropolitan ways of looking at things are wholly right. From its earliest years, we are anxiously told, Lincolnshire and Humberside Arts has been interventionist, assuming the role of a development (sic) agency, 'seeking solutions to perceived need and not just to articlulated demand'.

Yet nowhere does the report give the faintest indication that its authors know anything at all about the sub-cultures of their region. They do not seem to know anything about the rural traditions of the areas they speak for, and nowhere give the impression of recognising articulated demand, still less perceived need. Indeed they give no indication that they know anything about their communities, still less anything about the communities' artistic lives; all they know about is what bureaucratic structures exist. To take just one example of this - the breezy Lincolnshire resort of Skegness. This is how Alan Sillitoe describes it:

In 1873 a branch line was opened from Boston to Grimsby, and the first railway trips were run from Nottingham to Skegness. The rise of the place was due to the exertions and investments of the Earl of Scarborough, and now its a town of thirteen thousand people, flat, nondescript but with pleasant residential streets open to sea breezes from a seemingly immense horizon. Inland are Tennyson's 'wide winged sunsets of the misty marsh'.

The Golden Sands of Skegness, as the posters say, never change, but the pier is broken now, the end piece a kind of shabby rig supporting a few rooms and the remains of a tower. A man sells popcorn, and music blares from the arcades. Walking through the town at midday, the *Nottingham Evening Post* is on sale. There are tat shops, cafés (friendly flies around the trash basket outside), fish and chip places, seafood bars, and tuckshops selling whipped cream, candyfloss, doughnuts, slushburgers, hot dogs, milk shakes and coffee to take away. To shake the stuff around into a trifle there's the Ghost Train to Hell (20p per person), electronic horse riding, kiddie rides, video, twist, waltz, gallopers, dodgems, skyride, flying saucers, jungle rides, zkylon and pirate ship. The Death Valley voice from a bingo arcade sounds like a countdown into penury.

Skeggy is predominately a resort of the middle-aged and elderly. Either they can't afford Benidorm, or they want to come back to the favourite venues of their youth - maybe both. In 1964 a survey showed that seventy four per cent of visitors were family groups. Not much Mr and Mrs Smithing here, you might think. At one time the railway was threatened with closure, since eighteen per cent of visitors arrived by it, but for the moment the station is where it always was - half a mile west of the clock tower.

Recalling the terminology of arts council pronouncements, the readers heart may well have quickened as he read Mr Sillitoe's account. A town built on commercial investment from the private sector, and sustained by having a clear attraction to tourists! This, surely, is arts enterprise in action. But no, when we read the account of the same area in the regional strategy, it is as if we are speaking of a totally arid town, without any of the music and fun and schmaltz that Sillitoe describes. It has, it appears, lacked bureaucratic planning. Here is that very different account:

East Lindsey District Council, an Authority which in the past had traditionally shown little interest in the arts, had made considerable strides in policy and had seen a transformation of attitudes at member level over the past two years. The arts were now seen in

the context of economic growth and social provision. The new arts strategy was led by the Chief Executive and developed through the Department of the Director of Entertainment and Amenities, whose brief now included cultural resources. Internally, an officer had been redeployed to support the new arts emphasis.

'The arts' apparently don't exist - but attitudes, strategies and *policies* about them do. (No mention here of the town's traditions in church music, in amateur dramatics and amateur operatics, in garden design, in poetry writing; nor is there any mention of the rich tradition in popular entertainment, particularly in popular song and club comedy - the author saw the immortal Jimmy James give what was his last stage performance in a Skegness theatre - and of course no mention of the raucous and blowsy seaside amusements that have given the town its character.) Art is presumed not to have existed because the Council hasn't subsidised much of it, and hasn't developed a bureaucratic substructure to plan it. It is now assumed that it will grow in proportion to the appointment (or redeployment) of arts officials, and in proportion to increased local subsidies. The existence of a *plan* will lead to more Tennysons, more Jimmy Jameses. And, presumably, a better class of holidaymaker, as the articulated demands of the present ones seem of such little account to the arts strategists. (Of course, once Arts Officers are applying subsidies to the area the holidaymakers will become *tourists*.)

Singling out Skegness is not unfair. Throughout the report there is the same insistent belief that more plans, more bureaucrats in post and more funding structures will lead to more and better 'art'. Here, omitting only one authority which did not accept the plan, are the main recommendations for each of the areas covered by the report:

> Humberside County Council
> 'To consolidate the County's current practice and existing priorities into a comprehensive statement of policy...'

> Lincolnshire County Council
> 'To carry through the proposed interdepartmental Arts Development post for the County...'

Beverley Borough Council
'To develop an Arts Policy for the Borough which pays regard to rural areas and maximises potential for tourism and economic development'

Boothferry Borough Council
'To produce an arts plan for the Borough'

Boston Borough Council
'To develop a comprehensive Arts Policy for the Borough which maximises the potential of existing resources...'

Cleethorpes Borough Council
'To build on the opportunities presented by recent staff restructuring and prepare an Arts Policy for the district'

East Lindsey District Council
'To employ a professional consultant to investigate and report on the needs, problems and opportunities for arts and cultural activities throughout the district'

East Yorkshire Borough Council
'To capitalise on their recent staff restructuring and develop a plan for the arts in the Borough with particular emphasis on the need to build a locally supported infrastructure for arts promotion...'

Glanford Borough Council
'To develop an Arts Policy and programme for the Borough integrated into broad leisure provision, following the completion of the Arts Plan currently being commissioned'

Great Grimsby Borough Council
'To develop Grimsby's potential role...'

Holderness Borough Council
'To develop an Arts Policy which will embrace the needs of the whole Borough'

Hull City Council
'To commission a City Arts Survey (if it can be done without any financial cost to the Council)...'

Lincoln City Council
'To appoint an Arts Officer'

North Kesteven District Council
'To produce an Arts Plan for the District which should pay particular reference to Sleaford and other underdeveloped areas'

Scunthorpe Borough Council
'To develop a comprehensive arts programme which achieves a balance between professional and amateur provision'

South Kesteven District Council
'To develop an Arts Policy for the District'

West Lindsey District Council
'To develop a District Arts Policy'

The faith of the bureaucrats in themselves is undimmed, even by the gradual revelation that the area in which they pride themselves on having such a long record of interventionist behaviour is, in their terms, still so badly in need of 'development'. The authors seem to imply that they know what a developed area should look like (it should apparently *not* look like Sleaford, a very pleasant old town with a long and tranquil history, and a settled and harmonious old town centre.) They know such things as the proper balance between amateur and professional provision. And above all they know how it will be achieved - a lot more reports and a lot more arts officers in post. 'Development', a much-used word here, means bureaucratised.

This desire to have an arts officer in every town and village could remind us of the coming of some kind of cultural totalitarianism. Hitler's Third Reich for example had 8,000 regional arts officers in post and they, like other totalitarian regimes before and after them, set great store by three and five year development plans, with cultural targets to be achieved. But the kind of activity threatened by such publications as the Lincolnshire and Humberside report is of a far less menacing kind. All we are threatened with here is the gradual increase of a bureaucracy, with its own discrete language and its own bureaucratic practices, all of a kind that touches art and the real pleasures of most people comparatively little. Practically nothing that the RAA does will impinge upon the lives of most people in the area. That is because the bureaucracy is not fuelled by a coherent social view, and because it has no power to modify or change most of the things which circumscribe the ways

in which the people of Lincolnshire and Humberside seek enlightenment, pleasure or recreation.

What most formulated arts policies suffer from is simple confusion. Confusion as to subject matter - they shy away from any attempt to say what 'the arts' actually are, avoiding the difficult decision about whether you are to give any weight to amateur dramatics, or watching good comedians, or making a beautiful garden, or dancing at a disco, but using an all-purpose judgemental term in a way that means you can shelter behind it. Confusion as to scale then follows - many arts policies set ridiculously inflated aims, claiming that they intend the arts to cure all manner of disease, heal social conflict, promote economic wealth and lead the citizenry to the higher glory. Then there is confusion over the nature and scale of the means that they may be used to achieve these grandiose ends - the tiny grant, the minute venue, the tentative presentation that is always going to change the consciousness of mankind (and attract the tourists). But worst of all is the confusion in style of so many arts policies, as written. It is not merely that they veer from macro objectives to micro means, nor that they usually misunderstand economies, social processes, the nature of education and many other things they claim 'the arts' will reform, it is that they veer wildly between the three main ways in which a policy may be written, (i) prescriptively, (ii) descriptively, and (iii) reactively. The resultant confusion is often a turgid coagulate of all three, (documents which may, rudely, be said to be written *costively*).

9.1: Prescriptive Policies

A policy may be said to be wholly prescriptive when it seeks: a) to define the parameters of art, b) to control all means of artistic creation, and c) to control all the means by which the arts may be publicly or privately enjoyed. As we shall discuss in Chapter 11, a developing country is under an obligation to make prescriptive pronouncements about its culture in its earliest years. Advanced countries do not have that need, unless some pivotal change in the structure of society or the rights enjoyed by its peoples is being contemplated. A recent example of such a change may be found in Canada, where a social policy of multiculturalism underpins a

prescriptive new definition of Canadian art and culture. Much public and parliamentary discussion has accompanied the Canadian Multiculturalism Act 1987 and section 3 of the Bill is straightforwardly prescriptive, for example:

> It is hereby declared to be the policy of the Government of Canada to: (a) promote the understanding that multiculturalism reflects the cultural and racial diversity of Canadian society and acknowledges the freedom of all members of Canadian society to preserve and share their cultural heritages...
> (f) encourage and assist the social, cultural, economic and political institutions of Canada to be both respectful and inclusive of Canada'a multinational character.

9.2: Descriptive Policies

A policy may be said to be descriptive in nature when it makes generally available knowledge of all the existing definitions and practices which hold general sway within the country. Such policies do not set fresh targets nor propose new systems, but aim merely to disseminate knowledge about existing practice and announce an intention of sustaining what already exists. An important feature of this kind of policy is that it is complete in its disclosures about the system, and does not hide information, clothe its actual intentions in hidden metaphor, nor keep its procedures partly secret. A policy in this form does not seek to impose a persuasive redefinition of art, nor does it seek to impose systems of control; it is indeed possible for different notions of art to exist simultaneously and for control to be vested in various different authorities by this system; the government's task is limited to maintaining the various systems of support and control in the form in which they have evolved. It is usual to find policies in this form only in well-developed, stable societies in which the public institutions are well entrenched.

9.3: Reactive Policies

This form of policy is in broad terms the opposite to a wholly prescriptive one. It contains in some sense the setting up of agencies which react to requests and to wants of the arts markets, but does not involve any form of direct interventionism in them.

Artists, managers or audiences will make requests for aid or for advice when the usual mechanisms break down, but in normal times the government will intervene as little as possible in the ways in which artists meet their audience. The arts will be 'out there', subject to free critical pressures and in their sale subject to ordinary market forces. Government reaction to requests may either take the form of the removal of some hazards to the arts' activities (such as bad tax) or may be supportive (in the form of financial aid), but will tend to be short term, and of a nature that imposes no binding commitment on either party.

The Arts Council of Great Britain began its life as a body with an essentially reactive policy. The wartime organisation from which the Council grew, the Council for the Encouragement of Music and the Arts actually *advertised* in its first year in the newspapers the fact that it had funds to aid the arts and invited groups to write in and ask for help. That help was indeed then dispatched without any further investigation. That general attitude survived well into peacetime (though as we have seen the Arts Council jibbed at the overtones of the actual word 'policy' and would stoutly announce for some years that it hadn't got one).

Governments may of course have segments of policy which are prescriptive, segments which are descriptive and some that are reactive. It is however important to separate them and not (as has happened in many ministries and arts councils) confuse them by, for instance, affecting to offer a policy in descriptive form, but, by witholding a crucial piece of information, in practice working to a hidden agenda of a prescriptive kind. An example of this comes once more from the British Arts Council. In October 1987 it produced a document outlining two new financial systems, ostensibly described in a neutral way. The reader was given a great deal of information about how the Enterprise Fund and the Progress Fund worked: who was eligible, what kind of information would be needed and over what period of time, how applicants would be assessed and so on. It was all clear quantitative information, passed on by the Arts Council in the form of a descriptive policy statement. However two paragraphs indicated that there would indeed be other, more secret, steps to be taken:

> 1.5 It should be noted that all organisations which qualify either for an Enterprise Grant or for support from the Progress Fund may not receive assistance when they apply. Arts Council Enterprise and Progress Funds are extremely limited and many worthwhile applications may have to be rejected or deferred for a future year.

No indication there of what criteria will permit one project to be preferred to another, when both meet the published demands. So *who* will actually do the deciding, and what other powers might they have?

> 1.6 The Funds are controlled by an Enterprise and Progress Board; this is chaired by the Chairman of the Arts Council and its members include the Chairman of the Scottish Arts Council, the Welsh Arts Council and the Council of the English regional arts associations. The Board has the right to agree variations to the rules governing the Enterprise and Progress Funds in certain cases.

The affection of the descriptive openness is therefore a sham. A body which is accountable only to itself meets in secret to decide between applicants (who meet the published criteria) according to its own unpublished notions of priority. In this, as in many cases where the types of policy are confused, the ostensible 'policy' serves only to hide the real and secret one. Beneath the 'reactive' packaging is a prescriptive product.

Making a division between the prescriptive, the descriptive and the reactive is more luminous than categorising systems by the administrative form they happen to take, as in 'Ministry system', 'Arts Council system', 'Federal system' and so on. In both advanced and developing countries those administrative forms shade into each other; Ministries may well for example operate a system of peer group assessment, while Arts Councils may behave more secretly and more dictatorially than governments. Yet this three-way division is not in itself enough. We turn now to a series of rather more sophisticated models which may help to explain government motives in making their various interventions within the arts market.

10: Motives of Advanced Governments

It is a curious fact that although the governments of developing countries are expected to have a high-minded and disinterested concern for their national cultures, governments of so-called advanced nations are expected to have outgrown any such instinct. Appeals to governments for support of the arts, or for the modification of any form of intervention in arts markets are in general, in developed countries, couched in the most cynical terms. Governments have to be persuaded to support the arts for a variety of reasons other than the simple beauty and goodness of art.

These varied motives, cast in the form of a series of models for government action, are described below. They are based upon the models used for many years by Professor Titmuss in his seminal work on state welfare, but with the addition of one model which Professor Titmuss would one imagines have scorned to own. It is the model wherby governments are supposedly persuaded to 'invest' in 'the arts' because of an ultimate *commercial* advantage to them.

No government operates according to just one of these models. At various times governments will intervene in arts markets (in either a constraining or a supportive way) for each of these motives, and as habits die hard, governments will sometimes continue with 'support' when the original motive for giving it is long forgotten. In most advanced countries therefore the purposes of the existing government mechanisms are fuelled by different and sometimes contradictory ambitions. Each of the following is described as supportive, although at the end of the chapter we point out that each has a mirror image of itself in restrictive government action.

113

10.1: National Glory
'Glory' is rather an old-fashioned concept. Nevertheless governments are often persuaded to support arts projects because they impress the international community, because they become a recognisable symbol of that country's sophistication and civilisation, and because such projects live on down the centuries. Sometimes they do this in actuality, like the great theatres of the Greek city states, like the great Roman amphitheatre of Verona or the palace at Versailles. Sometimes they exist only in legend, like the Hanging Gardens of Babylon. But their name continues to bring glory upon the civilisations and governments that created them. When we contemplate them we think less of the cruelties of the Greeks, of the Romans or of King Louis XIV, then of their refinements and splendours; their glory, not their shame.

When governments are motivated by a desire for glory, Sir William Rees-Mogg's assertion that 'the political economy of the arts is dependent upon the political economy of the nation' is again seen to be partly false. However impoverished a government may be, it will often find the means to support a monument to itself. Britain was hundreds of billions of pounds in debt to the United States when it decided to hold the Festival of Britain and to leave, in the shape of the Royal Festival Hall, a monument to its postwar vitality. Shortly afterwards, city interests on the north side of the River Thames began planning the Barbican which, when it opened, had cost more than M£180 and could never, however vibrant the economy, be other than a loss-making enterprise. In France M. Mitterand chose to ignore the parlous state of both the economy and government when he announced the building of a second great Parisian Opera House in the Bastille at a cost now estimated to be in excess of M£800. On the other side of the world, in Soeul, the Korean government, technically bankrupt, sets out to build another huge international Arts Centre, to coincide with the staging there of the Olympic Games. The desire for glory, whether locally from a museum, a gallery or a concert hall, or nationally from some great project, is extraordinarily strong. For glory, financial constraints and political prudence will often both be overcome.

10.2: Inducement and Reward

Governments can sometimes be persuaded to see the provision of arts facilities as being a part of social planning, most often as being a desirable amenity in a new town, or a development area, where they will in effect be an inducement to industrialists and their skilled workers, and a reward to them for giving their skills to a new community. New towns are planned to include arts amenities, and in the redevelopment of city centres governments can often be persuaded to make heavy capital investments in what are thought to be attractive and desired amenities, which will be expected to help attract skilled and upwardly mobile people back into the heart of a city.

It is a common belief that industrialists and skilled workmen expect this sort of facility, but evidence about the truth of it is (perhaps inevitably) conflicting. In many new towns in Britain the arts facilities, so expensively put in place, have had to struggle to survive; although it may well be, to take one example, that the incomers to Milton Keynes are delighted to have the Jennie Lee theatre in their town, one could not deduce that from their attendence at it. And, nearly a decade ago, I recall being asked for an opinion as to why the Crafts Workshops in that same town were not working either. They had been provided - large, well-heated workshops, fully equipped for all kinds of craft work, and open all day to the local community - in the belief that they were the kind of arts facility that made the new town attractive to live in. They were there as a reward, intended to be part of the welcoming fabric of a new technologically-based community, an inducement to enjoy the kind of lifestyle the planners thought the residents should have. In fact they were hardly used at all. To rub it in, I came out of the last one I visited, which had also been empty, and stood for a moment on the chill autumn pavement outside. Nearby was a launderette, and inside it, about a dozen Milton Keynes residents were sitting happily daydreaming, watching their clothing spin.

Indeed one may be tempted to generalise and to say that good schools, good shopping facilities (shopping is no longer purely an economic function in advanced countries; it is an important social and cultural activity), open healthy spaces, good communications systems and good sports facilities are of much greater importance in attracting industry, or skilled workers, to a town than arts centres

and such like. However there is conflicting evidence, which both suggests that although incomers to a community may not use the arts facilities very much they feel pleased (as with the local churches) that they are there. Perhaps of more significance is evidence that attitudes towards arts facilities often improve over time. There may be hostility when a concert hall is first erected, but after a period it is more widely recognised as being a positive local amenity. This latter point has been well made by Professor Throsby, whose work on attitudes towards the arts and arts facilities in Australia has been highly influential. His surveys have demonstrated that over time attitudes towards new arts contres, for example, change considerably. People become much more positive about them, and often upgrade them in their minds as against sports and other kinds of facility. One example comes from Canberra, where a survey conducted by McNair-Anderson corroborates Throsby's findings. There the Theatre Centre, the first major civic arts centtre in Australia, is twenty years old. Attitudes towards it have over the years grown much more positive, to the extent that, in the words of Throsby's well-known co-researcher Professor Glenn Withers, the 'extensive involvement in theatre-going and gallery-hopping significantly exceed' those for Sydney, whose major arts provisions are of more recent date. In Canberra 71% of the population would now oppose any withdrawal of state funding for arts facilities, and they demonstrate their support in the most practical way. In 1986/7, 74% of Canberrans went to live arts performances and 71% to exhibitions, as against 42% who attended live sports events in the same twelve month period. It may therefore be the case that although incomers do not necessarily attend arts venues with much fervour, and although residents may at first be suspicious of the provision of arts venues, in this respect governments sometimes show an instinctive wisdom, for attitudes sometimes change and, over time, attendances sometimes rise dramatically.

10.3: The Placebo

Since the Romans supposedly quelled their mutinous citizens with bread and circuses, history has given us many examples of governments who appear to use the arts as a means of quelling

dissent, soothing dissatisfaction and inspiring populations to look beyond the sordid present. In times of economic hardship, or times of war, governments of all kinds distribute inspirational fiction, stage rousing and colourful national ceremonies, promote the playing of patriotic music, and display the riches of their art collections to their peoples. The arts are here seen as emblematic, sometimes a substitute for other kinds of nourishment which are lacking, and sometimes as a distraction from the insalubrious present.

Britain followed the practice in the First World War, when the network of Garrison Theatres was set up in troop camps throughout the country, and when the Foreign Office paid for touring theatre and music groups to entertain the troops on the mainland of Europe. It followed the practice with even greater fervour in the second, when companies from the Entertainments National Services Association (the biggest of many wartime support organisations for the arts and entertainment) sent out performing troupes of all kinds to distract and amuse the underfed and overworked factory workers and fighting troops. A peacetime example comes from the USSR, where the Soviet Government during the darkest economic period of the union, continued to publish a considerable canon of polemic, poetry and fiction and frequently to distribute it free in railway stations, shopping centres, and residence blocks. It was therefore possible for even the poorest citizen to assemble a modest library of political writings, short stories and poems.

10.4: Education
We are here using 'education' in its narrowest contemporary sense, that of 'training'. Governments in totalitarian states plainly see artistic expression as being a part of their training system - a powerful means of helping people to view the world in the way they wish them to view it. States however which are less than totalitarian will also frequently wish the arts to play a part in the education system which is inspirational, and will wish the arts to play a similar 'educational' role in national celebrations or festivals which are designed, in part, to celebrate and emphasise a governmental view.

Again, Britain has a long tradition of using artistic creations in this way, extending back at least as far as Henry VIII's closure of the religious foundations and monasteries in 1534. At least 1,000 foundations were closed, and this led to the unemployment of many lay musicians, who had hitherto worked independantly of the state. However, by accepting Henry as the new head of the church, and putting their musical talents towards the re-education of people within the new religion, many of the ablest were able to gain state-subsidised employment in the newly organised cathedral communities and in the Chapel Royal. Perhaps the most blatant example of the state enlisting the arts as a part of an education programme, however, was seen in Britain at the time of the Great Exhibition. There, artists, designers and craftsmen were all recruited to play a central part in the Exhibition, which celebrated the cultures of all nations, but which was plainly intended to celebrate Britain's character and achievements more than most. The state supported the Exhibition with fervour because of its serious educational intent, and those artists and designers who found employment in it benefited. From it, the systems of National Art Colleges and National Musical Training both grew. However, the artists and performers who were not included in the state largesse did correspondingly badly. London's theatres for example 'did not fill', and in general 1851 was a poor year for the rest of London's arts markets.

The United States has, since the war, seemed to offer a comparatively low state subvention directly to the high arts, but when the sum total of federal and state cultural programmes, particularly those which are allied with educational programmes, are assembled, one may conclude that the first impression is misleading. As we have said earlier, by simply judging a country by the percentage of the GNP it happens to give to its major arts funding agency, we run the risk of serious misconception. Arts support programmes are as thick on the ground in the U.S. as in most European countries, but they are in general more firmly intertwined with state education and community care activities, and so are less visible.

The publication by the Washington International Newsletter in 1972 of the Senate report on Federal and State Cultural Programmes, *Millions for the Arts* raised many eyebrows both

inside and out of the country*. The document for the first time listed 43 government agencies concerned with state funding of the arts (4 in the Legislative branch, 16 in the Executive branch, 12 independant agencies and 11 Boards, Committees and Commissions), listed 50 State Arts Councils and in each case listed their policies, programmes, budgets and attendences at their various venues and promotions.

It thus became clear how comparatively minor the 'official' state funding body, the National Endowment for the Arts, was in the overall picture. In 1970, for example, the total spent on grants by the NEA was $4,250,000. In that year the Army Entertainment Programme, itself responsible for more than 400 venues, spent $5,020,016, the Army Crafts programme spent $9,750,000, and the Army Service Club Programme (which operates the army library service) spent $11,189,053. In the same year the NEA was able to spend $2,000,000 on state-assistance in the arts, but the states themselves spent many times that sum. In 1970, New York State spent $2,300,000 on the arts on its own account, Pennsylvania $600,000, and Puerto Rico an amazing $1,450,000. Throughout the report, it is the emphasis on the arts allied with education which is striking, with schools, universities and youth programmes much more integrated with the overall programme than would be the case in most European countries. Thus Florida, which might seem from the listings of NEA grants to be almost an art-free zone, is seen to be active, and its state council fully supportive, when its education-related programmes are listed. In 1970 its future plans included support for:

> Bethune Cookman art and drama in connection with Jackonsville University Festival of Fine Arts
> University of South Florida Art Bank
> International Music Festival at Statson University
> Lemoyne Art Foundation leadership education programme
> Marymount College art participation and analysis programme
> Ringling Museum, History in Architecture
> Stephen Foster Liberal Arts Course for Young Adults

* A year after the U.S. had realised there might be 'something' in the arts. See Chapter 6.

Such activities are supported because, in general, they are thought to assist in the training of good American citizens.

It is of course noticeable that when arts education programmes are seen as having played a part in the fostering of dissent, or of unpatriotic sentiments then state support will be withdrawn. That process has recently been evident in Britain, where a considerable amount of indirect state aid has been withdrawn from the state education system in the arts and humanities partly because it has been believed that the system is promoting deviance and dissent, in particular by questioning the apparent values of the present government. The arts have a much-reduced role within the new National Curriculum which is being devised for state schools. College and University courses in the Arts and Humanities have been under particular fire.

10.5: Welfare Service

Governments sometimes legislate for the right of equal access to some part of the national culture for all citizens, and will at such times finance the nationwide provision of arts centres, workshops, or arts leaders so that the principle may be implimented in practice. There are times when, whatever government's original intentions, the high principle proves impossible to finance in practice. Malraux' *Maisons de la Culture* scheme, for example, which was to have given the whole of France the kind of venues which are a feature of state provision in Poland and Chekoslovakia, proved too expensive in actuality, and only two ever opened. Sometimes, however, government fully funds the welfare scheme. Again, an example comes, somewhat unexpectedly, from the United States where during the depression the vast Federal Arts Programme took animateurs to every corner of the country; thousands of arts activities and hundreds of arts centres were set up. Although it was a spectacular piece of welfare legislation in its time, and had no doubt a placebo effect as well, it is hard to detect any lasting effect that it had, on art, people or federal government attitudes to the arts in that country.

Examples of the arts as a state welfare service can readily be found in the West. The British state library service is one prime example (at least until recently, when government cutbacks

radically affected its purchasing powers and forced some parts of the nationwide service to close). The 1,600 museums of West Germany constitute a second. In the communist countries of course most arts provision is made according to this model, and in those countries that is allied to a strongly directed programme of attendence. This will mean for example that virtually every child in Moscow will have visited each of the major Moscow museums as a part of their studies, and that all citizens within travelling distance of that city will have been part of adult groups visiting not only the museums, but the galleries, theatres and concert halls. The provision of arts welfare facilities in countries which do not have that degree of control over people's cultural activities is of course no guarantee that in such countries they will be used. H-J Klein, in his *Analysis of Visitor Structures in Selected Museums in the Federal Republic and West Berlin* (1984) has for example pointed out that between 60% and 76% of the West German population must be regarded as 'chronic non-visitors'. On average only about 10% of the population make more than five museum visits a year.

10.6: Compensation

Governments may sometimes be persuaded to compensate for the comparatively harsh treatment a minority group may have received by funding arts programmes, or commissioning artists, especially for it. Thus many governments, national and local, will at various times be persuaded to discriminate positively in their funding of activities for certain ethnic minorities, recent immigrant groups, the unemployed, the old, disabled or other disadvantaged groups.

The puny scale of some compensatory aid to minority cultures can sometimes be cited as evidence that governments find this a cheap and simple way of salving social conscience. In Britain there has been no positive move towards multiculturalism, as there has been in Canada and the United States, but rather some general legislation aimed at preventing discrimination against ethnic minorities; the aim has therefore been, rather uneasily, to give black immigrant groups equal opportunities within the prevailing white British culture. In spite of this legislation, there has nevertheless plainly been great discrimination against Black Britons. Most of the worst areas of inner city dereliction in Britain

contain a disproportionately high number of black groups, and a disproportionately high number of those are unemployed. The third Policy Studies Institute survey *Black and White Britain* (1984) showed that people of Carribean and Asian origin were most frequently found in areas of high job shortage, essentially the bad inner city areas of Britain. Even those in employment often found themselves at a disadvantage. In 1983 in Britain the average gross weekly income for white men in employment was £129, compared with £109.20 for those of West Indian origin, and £111 for Asians.

The labour force survey of 1985 gave an average unemployment rate in Britain of 11%. That comprised 10% amongst whites and 20% amongst blacks. There is a black labour force in Britain of approximately one million, so to redress the balance one would have to put 100,000 black workmen back in jobs. If this 100,000 were to be taken proportionately from the inner cities where most black people congregate, it would mean that in London there would have to be 33,000 new jobs for blacks, in the West Midlands 20,000, in Greater Manchester 15,000 and in other inner city areas some 32,000. The task is truly daunting. For example, figures from the Institute of Employment Research at Warwick University point out that although the unemployment rate in the West Midlands overall is around 13% for men, in Sparkbrook and Handsworth - two adjacent run down areas in the Birmingham city centre with a very high black population - it is over 40%.

In such circumstances one must consider the possibility that a compensatory policy in the realm of the arts is, for government, a useful distraction from the more basic requirements of such communities - decent homes, jobs, protection under the law from harrassment, positive education. Providing venues in which ethnic groups may enjoy their 'traditional' arts can be much cheaper than providing decent housing. Putting aside funds to aid the 'protest art' of unemployed blacks may be a useful way of channelling potentially dangerous protest into the relatively harmless realms of housing estate murals, sponsored graffiti, and warehouse discos. Within the white community it can merely be a form of conscience soothing, an act of tokenism.

Even if one could be satisfied that the general intention was a serious one, and Britain had an arts funding policy that had come to grips with funding the full range of minority ethnic groupings in

the land - if, that is, there were a financial commitment on the necessary scale (for black ethnic minorities at any rate do not have the kind of spending power that enables us to argue for their economic benefits in the way that funding arts for tourists is argued for) — then it is still hard to see it as more than a mildly diversionary tactic. Only if there is a policy of multiculturalism in all government services and in the law, only if there is positive discrimination towards giving black workers real jobs, and only if there is a positive commitment to rebuild the houses, provide education and health facilities and fairly police those inner city areas will an arts policy have a context within which it can be effective. When those conditions are *not* met, it is hard not to see the arts policies (however well-intentioned) as being a form of false compensation.

10.7: Commercial
John Myerscough, Senior Fellow of the Policy Studies Institute in London, gave the America-European Community Association's Arts Conference in 1986 a summary of his findings at that date in the research he was conducting on the economic importance of the arts in Britain, research sponsored by the Government Office of Arts and Libraries. He told the conference that there were four points common to the countries represented in the Council of Europe's deliberations on financing the arts. They were:

(i)	That arts organisations were increasingly turning to the private sector for 'funds';
(ii)	That the emphasis in public funding was moving from central government to regional;
(iii)	There was now 'assessment' of 'value for money'; and
(iv)	A realisation that new arguments were needed to stimulate 'support', the economic case being 'particularly relevant'.

This is an admirable summary of what governments think of as key issues of common concern at the present time. However, this is of course to make the modish assumptions that (i) 'The arts' *are* those activities which are in need of some kind of subsidy - nowadays called 'funding' - rather than the majority of creative activities which pay their way commercially; (ii) There is no alternative to 'funding' being a government concern; if 'funding' is to come from

the private sector, it must be by government-stimulated schemes, involving some kind of government 'assessment'; (iii) 'Value' is nowadays not spiritual, moral or social value, it is financial, as in 'value for *money*'; and (iv) As the assessment must be on economic grounds, so must the arguments for arts organisations stress the economic case. It is important, before we move forward, to emphasise that each of these assumptions is a *political* assumption. No bleary reference to 'the times we live in' or 'the ways things are' should allow us to forget the fact that we discuss the arts in those terms simply because we choose to. Nothing in art itself predicates any of these notions. Although the unspoken premise seems to be 'The arts by their nature can only survive in the modern world by these means', in fact the real hidden premise is *'Governments have decided* that these are the conditions under which they are going to permit art to exist.'

Once again, we have to notice the subtle misuse of two key words. The first is 'funding'. Used correctly, something is funded when it has its own financial assets, and is enabled to live upon the income derived from them. Arts organisations which live in this way - like the opera house at Glyndebourne for example - do not need to be grant-aided by government. If governments believed in *funding*, they would have voted sums of money to favoured arts organisations in the form of funds, which would have yielded interest sufficient to sustain them. It is incidentally interesting to notice that when people debated the whys and wherefores of state support for major arts organisations before the First World War they assumed that it would be in the form of genuine *funding*. However they also assumed that governments would be able and willing to relinquish direct control and governmental 'assessment' systems. In the event the annual grant-aid system and assessment of whether the government is getting 'value for money' have melded in many countries into one control system.

Mr Myerscough goes on to give an important warning that the economic impact of the arts must not be overstated, and then he indicates the five areas in which the arts may seem economically to 'score high':

(i) They have a very high value added.
(ii) They are labour intensive in relation to many other industries.

(iii) They provoke a large level of ancillary expenditure
 which stimulates allied activity
(iv) They have a high linkage effects into the local economy.
(v) They have a high additionality and low dead-weight
 expenditure.

A summary such as this necessarily blurs much that is more sharply defined in the final report, but it is still necessary to point out yet again that by blurring the arts all together as 'they', the reader is tempted to consider the many exceptions within the different arts world to each of these propositions. Some arts have virtually no linkage effects into the local economy to distinguish them from other activities; what economic effect is there for example for the county of Cornwall from the high number of well-known authors who choose to live and write there? And the labour intensiveness of painting, video-production, writing and publishing poetry, producing plays and running a puppet theatre are, for example, all so different that it calls into question any generality about 'the arts' in this area.

Most difficult of all is the generalisation that 'they' have a very high value added. Two caveats must be entered here. The first is that 'value' (the second key word to be misused) is here used, as it is often used in the mouths of modern arts bureaucrats, in such a way that it smears over the difference between aesthetic value and economic value. Of course the two concepts are linked. One would like to believe that things of high aesthetic value come to have a high economic value put upon them - if there were not so many examples in history of good things being neglected and their creators dying, unrewarded, in poverty. But sometimes it does work that way around. What is, however, objectionable in the modern blurring of the terms is that it hides the awkward fact that nowadays putting a high economic value on something (a picture bought by a well- publicised millionaire art collector for example) leads us to *place a high aesthetic value upon it as a consequence*. There are few modern critics willing to say that the Emperor isn't wearing any clothes, and that the expensive picture is trash. The 'high value added' by society to some of its paintings, to some of its literature, or indeed to some of its musicals, may be the kind of economic phenomenon which can collapse as rapidly as earlier financial bubbles, when the social climate changes and people no

longer wish to celebrate affluence and the tastes of affluence. Charles II's penchant for asking folk musicians at his court to sing 'all the bawdy songs' they could think of, gave such works a high value, but the bubble burst when the times changed. There is no guarantee — to take one example — that the high 'value' society may seem currently to attach to the musical theatre of Andrew Lloyd Webber, will survive for any great length of time. As Mimi Kramer wrote, reviewing 'The Phantom of the Opera' in *The New Yorker* (8th Feb. 1988):

> This is, after all, the age of the mindless, non-verbal musical - a form of which Andrew Lloyd Webber is the chief exponent. The kind of musical theatre he has come to stand for is one in which every aspect of production is subjugated to a notion of spectacle, that seeks to impress an audience with financial rather than creative prowess - with a demonstration of how much money can be put on stage. Central to this sort of theatre is the concept of doing something difficult or unusual - turning a Broadway theatre into a junk yard or a roller rink, writing a Broadway musical with no dance in the first half and no song in the second, without regard for whether the feat is worth doing. It is a matter of small importance to the audience that the actors in these shows look nothing like cats or trains, that the wordless portion of the separatist musical has no good dancing, and the danceless portion no good song. Achievement here lies not in the ingenuity or skill, or even in the gimmick concept, but in the idea of extravagence itself.

Art thus blends into fashion, and fashion into conspicuous consumption, and the circle is completed by the act of affluent promoters throwing their money about becoming a kind of high kitsch art. But nothing is happening which affects the notion of value in its older, moral sense, and the high economic value put upon all of this kind of 'art' is precarious.

Even when we have voiced reservations about the habit economists have of treating 'art' as if it is all of a kind, and even after we have pointed to the confusions inherent in the misuse of the words 'funding' and 'value', another difficulty remains. There is a basic contradiction involved in trying to demonstrate that the arts are ultimately commercially profitable in order to argue for more government grant aid. Or, to look at the contradiction from another direction, it is hard to persuade profitable industry to aid

the arts by arguing that the arts are themselves a profitable industry.

Of course the argument is not presented in such crude terms. Governments have tended in the last decade to suggest that the private sector 'tops up' government grant-aid, and another faintly obnoxious modern phrase has thus been born. It is now recognised as being politically correct to have *Diversity of Funding*. Indeed in some extreme cases it has become a definition of good art. The best art is not to be recognised by its significance, by its beauty, by its challenge, but by the political credentials of its sponsors. Here is the British Arts Council describing the aforementioned statue which has been proposed for Leeds. The work looks like a mummified commuter, of indeterminate sex, as it has no sexual or indeed personality characteristics. One might indeed say it is as nearly without significance or meaning as a piece of statuary can be. However, these are the enthusiastic terms in which the Arts Council describe it:

> Following a unique feasibility study commissioned by the Arts Council, leading sculptors nationwide were invited to submit designs for a new landmark in Holbeck Triangle, Leeds, a piece of waste land between the railway lines leading into the City Station. With backing from the Arts Council, British Rail, Leeds City Council and arts groups in Yorkshire, sculptor Anthony Gormley was commissioned to produce the special large-scale work which will give train travellers a dramatic first impression of the city.

'Brick Man' may indeed have a further significance. It can stand as a symbol of the modern 'Value for Money', a celebration, not of private affluence, but of public parsimony, regression disguised as 'development'. If, that is, it is ever erected, and if it remains unmolested by the citizens whose unarticulated needs it meets.

10.8: Order and Control
Each of the forgoing models of government behaviour involves a degree of support for the arts - a support which may be partial, may be unjustly discriminatory, may be crude in application, but support nevertheless. However, as we have argued throughout this

book, governments seek to constrain artists and art markets more than they seek to encourage them, and for each of the 'supportive' models of government behaviour, one can match it with a model of negative government action.

As governments wish to promote some aspects of their national art for their national glory, so they will seek to suppress other activities. They will use the arts in some instances as a reward, and the lack of them in others as a punishment. As they will sometimes use the arts as a compensatory tool for a disadvantaged minority, they will deliberately permit deprivation of other groups of their activities. It is therefore possible to sketch out a simple pattern of government modes of action which affect the arts, with positive and negative balanced (see Figure 3).

In so-called advanced societies, however, the systems of constraint will almost always be the longer-established, and the more powerful. In such countries the needs of the arts are less for growth and development, than for the shackles of constraint to be removed. The situation is quite different in third world and developing countries, one of many reasons why it is inconsequential and wasteful to suggest that the complex arts financing systems of Britain or the United States should be replicated in them. It is to their problems that we now turn, looking for the first time to societies in which the word 'development' does not have the sinister overtones it often has in 'advanced' nations.

GOVERNMENT MOTIVES

Supportive	Restrictive
National glory	Suppress the undesirable
Inducement and reward	Deprive and punish
Placebo	Incite pro-establishment sentiment
Education	Disenfranchise from national cultures
Welfare service	Limit and cancel existing systems
Compensation	Isolation of minorities
Commercial (unrestricted)	Narrowly licensed commercial activity
Subventions	Taxations
Permissions	Licensing restriction
Political support	Political hostility

GOVERNMENT TOOLS

Figure 3: Government Models for Action

11: Arts Policies in Developing Countries

The basic problem in developing and executing a policy in the developing countries is, just as we have seen in the case of the 'advanced' countries, frequently one of definition. The difficulties arise from the now-familiar attempts to seperate the high 'arts' from the common culture. In developing countries also the tendency is to downgrade or to suppress local, village, folk and tribal cultures, and to substitute for it a hybrid kind of national art, an imposed symbol of a 'new national consciousness', paid for and controlled by government. As with the advanced nations, segments of traditional cultures tend to be resurrected for commercial rather than for social purposes; old customs, ceremonies and crafts are more likely to be brought back to life for the benefit of the tourist market than for the benefit of the indigenous populations.

11.1: The Arts in Pre-colonial, 'Underdeveloped' Societies
In pre-colonial societies traditional art forms expressed life through the mediums of sound and spectacle. As in ancient Athens, and in most Western nations prior to their industrial revolutions, Art was not separated from 'real' life - but artistic expression was intimately bound up with commercial, political and religious life. In such societies 'art' is not a diplomatic counter that can be traded between cultures, but something which can only be understood by examining it within the traditional life of its progenitors.

Musical games played by children, for instance, prepared them to participate in all areas of adult village activity such as fishing, hunting and farming, participating in weddings and funerals, and in the gathering and celebration of the harvest. In many African and Asian societies life was interwoven with rituals, ceremonies

and festivals in which music, drama and dance were compounded into a total communal activity, in which the arts were not a diversion from reality, but contributing to reality itself; they gave life meaning, and could be said (as in the case of the Yoruba talking drums) to be a part of what it was to be human. What would in a more disjointed society be called a 'lifestyle' in a traditional society was simply life. Existence was given human meaning by the ceremonies which marked birth, death, marriage, emergence from adolescence, hunting, harvesting, the opening of a new home, the 'capping' of a new Chief or the 'turbanning' of a new Emir. The Eurocentric compartmentalisation of the arts into rigid compartments of drama, opera, ballet, classical music, poetry, the novel and the like is hardly applicable to an 'underdeveloped' society, and can lead one to even more ridiculous conclusions about the quality of life within it, than the habit of separating out 'the arts' from entertainments, popular pastimes, folk culture and the rest. For there was an intricate and close relationship between what we later came to call 'art' and underdeveloped societies. The Yorubas need music to create poetry, record history, educate children, celebrate festivals and simply to communicate with each other. The Indian knowledge of God is expressed in proverbs, short statements, prayers, myths, stories, songs and religious rituals and ceremonies. Traditional Guayanese and Latin American societies used the drum as a means of communication between the Gods and human beings.

The traditional patterns of arts patronage in these societies were also deeply embedded within the social systems, and could not readily be replaced or transferred from one community to another. It was often a remarkably sophisticated process,. For example the Hausas (a tribe which spans the whole region south of the Western Sahara) had a complicated form of patronage. Their court musicians ('massu gangan fada') were patronised by chiefs, emirs and senior court officials. The court jesters ('wawan sarki') were patronised by the same sources, but other kinds of entertainers and musicians were patronised by other professional groups, including, in the case of musicians, the Butchers. Artists received gifts in the form of land, money and honours. The Palace and royal families maintained permanent orchestras in their courts; wealthy families invited musicians and performers to appear at their family

gatherings and celebrations; whole villages took part in festivals which contained all forms of aesthetic expression within the society's culture, ranging from the simple exhibitions of basketwork, gourds, or calabashes, batik prints and weaving to complicated acts by masquerades, conjurers, dancers and acrobats. Through these delicate and interwoven patterns of patronage and commerce, the cultures and the various art forms of traditional societies were handed on from generation to generation, without deliberation as to which of the art forms was 'worthy' to be subsidised or not. No separate strategies needed to be devised for 'development', because strategy and development were both subsumed within the notion of continuing to live within the common culture.

It is of course too easy to fall into the prelapsarian myth, assuming that all technologically primitive societies were, before colonisation, tranquil, harmonious and culturally rich communities in which all peoples were happy and fulfilled. There was of course ignorance which bred fear; there was hunger which bred brutality and there was inevitably disease of the mind and body. What such societies do show us, however, is that it is possible for the arts to be so bound up with the life of the whole that no separate 'arts policy' is necessarily desirable or indeed possible to formulate, that in such circumstances there is no need to question the 'value' of the arts (still less their purely *commercial* value), and that systems of 'assessment' and 'development' do not necessarily lead to a richer life for all citizens; indeed the quality of life does not depend on those processes at all. And, most important of all, they remind us that art, and such traditions as there may be for promoting it, both derive from the common culture; it is that which gives them their significance and their quality. You cannot, by imposing a supposedly 'better' art upon a society, somehow raise its cultural standards. You can only depress its cultural standards by suppressing or downgrading the traditional arts, and by trying to impose alien forms in their stead.

11.2: Colonial Interference and Cultural Disintegration
The first main consequence of colonialism for the arts is that usually colonisers have combined peoples and tribes of quite different

cultures to form commercially exploitable units. Such rapidly created conglomerates of different ethnic and social groups had to have imposed systems of cultural planning as none of the long-standing cultural traditions of each of the group is applicable to the others within it; groups long separated by history, language and hence culture, whether in Asia, Latin America or Africa, found themselves bound together in new 'nationalities' by their colonisers and found that, as a part of the bureaucratic process involved, their traditional cultures had been downgraded by comparison with the newly imposed one.

Uganda for example is compounded of some forty different small nationalities (pejoratively referred to by the West as 'tribes'), including Langri, Medi, Alur, Lubara, Baganda, Bagitsu, Banjore and Batese. The peoples referred to as 'Jamaicans' include slave settlers from many different races and tribes including Africans, Syrians, Chinese and Jews that were deposited on the seemingly 'wasteland' island after the abolition of slavery. The term 'Nigeria' was a name conferred on a collection of over two hundred tribes in the British protectorate of the regions around The River Niger and Benue River basins in 1914. The list is endless. After colonisation, however, the main problem facing cultural and arts administrators in the developing countries inevitably is, 'Whose culture shall we promote, for whom, and in whose language?'

Some indication of the nature of the problem is given by the tortuous way in which advanced countries have set about trying to formulate educational and cultural policies for their ethnically diverse immigrant groups. But those problems, serious though they are, are minute in comparison with those facing countries created by colonisation. In the advanced countries questions about the dominant language, the dominant religion and hence the dominant cultures are settled; in the new countries each of these has to be decided. And in the newer countries the decision does not affect only a minority, it affects all aspects of life for all the country. In such circumstances the formulation of cultural policy cannot become the political toy of a minority, harmless to the majority whose way of life is well established; it is of profound importance to every citizen. Arts administrators in developing countries have not the luxury of making mere 'interventions' in existing arts markets, or of 'developing' local cultures, they have to work for the

country as a whole, forging order out of chaos, reason out of anarchy; they have to see what may be a common culture for peoples who speak in different tongues, sing different songs, worship different gods, eat differently, dress differently, hear, see and live in utterly different ways.

The colonisers added a further dimension to the problem. They brought together, for commercial convenience, quite separate cultures. They also, in order to standardise social and religious administration, imposed their own cultural values and administrative systems upon their hybrid creations. This involved first the downgrading of indigenous art; missionaries categorised traditional celebrations and ceremonies as fetish, pagan, primitive and heathen. Then, through the introduction of the colonisers' education systems, the virtues of the colonisers' language, religion and art were promoted. Subject peoples started to abandon their traditional names for 'better' names; in Africa names such as William, Peter, Anthony - more familiar in the Home Counties - became common. Church music replaced much traditional music. The colonisers would import cutlery to teach 'better' ways of eating, and would import their own fashions of dressing for the subject peoples. In schools pupils wrote, talked and sang in English, French, Flemish or Latin; they learned the plays of Shakespeare and the poetry of Tennyson. Traditional cultures thus disappeared, or suffered much erosion, and were 'replaced' within one or two generations by a colonial culture, everywhere promoted as 'better', more 'civilised' and of 'higher standard'.

What was traditional was assumed to have belonged to a dark age, something coarse and primitive, of interest only to social anthropologists. Again, people living in advanced countries can see something of the process by looking at the way in which their modern arts promotion systems tend to denigrate the rural, the old and the traditional within their urbanised and 'sophisticated' societies. But again, it is only the merest indication. The shift from rural to urban life, and the various stages of industrialisation have been in countries such as Britain, Belgium and France comparatively slow. The spread of the media throughout these (fairly small) countries has also ensured that identities have in any case over time become blurred. There is no such thing in Britain as a completely rural person any more. In the colonised countries

the changes have been bigger in scale and have been much more rapid. They have also been more total in their affect. In Britain an arts administrator may wonder which of many cultural strands should be preferred. In a developing country the arts administrator has no such luxury; he or she must first retrieve 'what has been lost' before 'what we have' can be celebrated.

In nineteenth-century Latin America and in twentieth-century Africa the struggles for independence have forced that crucial question to the forefront. How can we retrieve what has been lost? What in any case should be retrieved? The questions are made more complicated still by the fact that the colonisers' cultures had, inevitably, become embedded within the various emergent countries' systems. Their bureaucratic systems which sometimes carried over into independence had within them systems of patronage, systems of state censorship, systems of state education which meant that it was almost impossible to take a coherent 'step backwards' into the traditional cultures. Of all these systems, bureaucratic ways of licensing have been the most significant. The colonisers have brought diverse homelands into one system of land control, licensing for specific uses. There has also been licensing of the various developing professions, licenses for uses of particular buildings, licenses to travel, systems of copyright, licenses to publish and to broadcast. In the post-colonial era the citizens of emergent countries have found that ressurecting aspects of their traditional cultures now require a series of state licenses and permissions.

The fact that much of the traditional culture was no longer practised as a central part of community life, coupled with the undeniable fact that the colonisers' cultures had become inevitably embedded within the emergent state systems, led to the promotion before and during the independence period in many countries of a hybrid culture, created from new art forms in which traditional cultures had become fused with those of the colonials. This was particularly so in African and Afro-Carribean states. There were in these countries new musical styles such as 'Ska', 'Rock Steady' and 'Reggae' in Jamacia, 'Calypso' music in the Carribeans, 'High Life' music in Ghana and 'Afro Rock and Afro Beat' in Nigeria. These and other similar forms were immensely popular in the fifties and sixties in the countries of their origin; they then spread

worldwide and, curiously, African and Afro-Carribean performers such as Might Sparrow, Bob Marley, Jilly Cliff and Lord Kitchener became immensely popular in Europe and the Americas.

The process was not limited to music. The new 'fused' arts of the emergent nations achieved great commercial success in the rich markets of the English-speaking and French-speaking countries from the sixties onwards. Novelists, poets and playwrights from the emergent countries found fame and fortune by writing for the former colonisers' markets, in their languages. Novels, poems and plays written by the likes of Wole Soyinka, Ayi Kevei Armah, Birago Diop, Chinua Achebe, Efua Sutherland and Ngugi Wa Thiongo became accepted by the international community as works which can be included in a world literature. From Jamaica and Latin America works by Trevor Rhone, Cortcizar, Garcia Marquez, Fuentes and Vergas Llosa all rose with some rapidity to a position of considerable international prominence.

The emergence and commercial success of such work however highlight further the problems of cultural planning in new countries. The initial problem was one of language. Emergent nations were still expressing themselves too often in the language of the former masters; to interact internationally, or nationally, artists were apparently forced to express themselves in a language which was not their own first and natural one.

The second problem the commercial success of the new artists often highlights is a cultural one. They are expressing themselves in the cultural modes taught to them in an essentially colonial education. The playwrights will have been to a Theatre Arts department in an African University, say, but there they will have learned little about the rich and complex dramatic traditions of Africa. That will, at best, have been a minor option. Instead they will have learned by study of the works of Shakespeare, Marlowe, Ibsen, Chekov and Brecht. The same story can be told elsewhere. The Jamaca Philharmonic Orchestra, The National Ballet of Cuba, the incipient Zimbabwian National Theatre have all in their different ways modelled themselves in style and content of performance upon the European nations' prized institutions. Their national writers, composers, designers and choreographers will therefore tend to write and create for them in a similar mode. They will be a part of the international arts currency, and may well be

commercially successful, but they will be incomprehensible to many of their own people.

The emergent state may wish therefore to rediscover and promote traditional cultures, to revive the arts that once were at the centre of life and which made belonging to that country, that race or that tribe uniquely meaningful. He or she will however find that in a country which speaks the language of the former colonialists, which has inevitably adopted many of the bureaucratic systems of the former colonialists, and in which commercial success is plainly to be gained by breaking into the markets of developed nations, that the task is a daunting one. The new technologies have aided a process which has meant that, whatever pieties may be offered (and indeed decently intended) about freedom and human rights, the richer nations are inevitably cultural colonisers. In Nigeria, for instance, 'Bata' dancers, 'Bori' dancers and the original 'Atil guru' dancers are all virtually extinct, but four-fifths of Nigerian kids can do 'break dancing'.

Plainly emergent countries need to find an alternative to being sucked in to the commercial and the state-subsidised arts systems, where a nation's culture is deemed only to be significant for its commercial value, or its weight in cultural diplomacy. That alternative plainly involves a drastic revision of state education systems, from nursery schools to universities. A curriculum needs to be created in which the works of Shakespeare, Marlowe, Ibsen *et al.* are not denigrated, but take their place alongside national writers of stature. In Nigeria this would means a serious study of indigenous artists such as Kola Ogunmola, Duro Ladipo, Moses Olaiya, and it would also mean some revision in studying the nature of drama itself. Of the two, the second may be harder to achieve. The most pervasive notion left by the cultural colonisers has been the insistence that the status and excellence of a nation's culture must always be judged in those old European categories of classical music, exhibition-worthy paintings, and conventional spoken dramas performed in conventional circumstances on conventional stages. To suggest that excellence may lie, indeed certainly *does* lie within forms unfamiliar to the bureaucrats of advanced nations involves going against the powerful tenets of several generations of educators, but it must be attempted.

11.3: Colonialism and the Third World Economics
In order to understand the difficulty of the attempt, some examination must be made of the underlying forces which inhibit public and private provision for the arts in developing countries, as well as access to them. It is important to understand the 'cycle of underdevelopment', for, in the words of Claude Ake:

> Once we understand what the material assets of a society are, how the society produces goods to meet material needs, how the goods are distributed and what types of social relations arise from the organisation of production, we have come a long way to understanding the culture of that society, its laws, its religious systems, its political systems, and even its mode of thought.

Colonial administrators tried to exploit the maximum possible revenue from the agricultural and the mineral exploitation systems of their colonies, with minimum transformation in production and labour systems. This led to the economic underdevelopment of colonised countries, and disadvantages them in comparison with the core regions of the capitalist world economy, whose production and labour systems have been allied to their needs. Systems in colonised countries are not however allied to their own needs, but to those of the capitalist world economy.

The main objectives of colonisers generally involved the supply of raw materials to the capitalist markets, in return for manufactured goods. This had several repercussions. First, this meant that the manufactured goods cost far more than if they had been manufactured in the purchasing country; meanwhile the same country was exporting its raw materials for less than their ultimate worth to their original owners, and denuding itself of valuable resources in the process. This cycle of underdevelopment involves a permanently unbalanced budget, for the country has to deplete its natural resources at an ever faster rate in order to pay for the manufactured goods it has to import.

As colonisers would wish to concentrate upon the most lucrative and most readily exploitable materials to export, the tendency was always to turn third world economies into 'one product' systems. These exported materials were usually a limited range of mineral products or one agricultural one. Thus when it was undergoing this kind of exploitation Ghana had its cocoa 'developed' from a stage

when it accounted for 20% of export sales to 80% in six years. In the sixties the production of cotton, cocoa, and groundnuts multiplied tenfold in Nigeria. But markets fluctuate, and economies which rely upon such a narrow band of exports run terrifying risks of sudden economic collapse. When one adds to that the obvious needs for capital and educational investment in countries emerging from colonialism, the hideous damage inflicted by flooding, drought or other variations in weather, and the increasing demands arising from an uncontrolled and growing population, something of the problem may be gauged. Coupled with all of that is the effect of international financial arrangements, the flight of capital from newly independent countries, the high cost of borrowing, and the spiralling disadvantages of third world currencies in the foreign exchange rates, all making the economic conditions almost intolerable. The result is that many newly independent countries which fed their peoples before they were colonised now, after the colonial period, have to try to import food for their peoples, and the cycle of underdevelopment makes it dauntingly difficult to increase either their agricultural output or their exports at anything like the required rate that is needed to help pay for such imports. Between 1970 and 1975, to give just one illustration, the rate of population growth in Africa was 2.7%, and the growth rate of agricultural production only 2.5%. The results of that widening divide have been evident ten years later to the whole world. Perhaps most dramatic of all is Latin America, where once there flourished great civilisations - the highlands of Southern Mexico, Guatemala, Peru, Bolivia - and where there is now only an impoverished and oppressed continent.

The effect of all of this on 'arts policy' is obvious enough. There is hardly any money, and there are few resources, to try to build a coherent culture from the very different communities that colonisers have lumped together. The priorities must lie elsewhere, in feeding the hungry, and healing the sick. The infrastructures have to be built by which people can be housed, can travel, can be educated and given longer term health care. There is no money left for arts subsidies or for building venues to entertain the tourists. The kinds of things people say in the 'arts policies' of the advanced nations about 'the arts', that investment in them brings jobs, boosts the economy, attracts high-spending tourists and develops civic

pride, seem so much mumbo jumbo when applied to circumstances in third world countries.

It is worth going a little further in our brief exploration of the economics of the newly independent nations of the third world. They variously suffer from misplaced external advice and from internal problems which their economic difficulties help to create. Amongst the malign external advice is that which comes from the International Monetary Fund. The IMF draws developing countries into what is known rather bleakly as the 'Debt Trap'. It gives its loans *on condition* that the recipient country abolishes or liberalises its foreign exchange and import controls, and devalues its exchange rate. This in effect means that the recipients must dismantle controls that have been set up to safeguard a reasonable foreign exchange rate. This is suicidal for countries which are almost always suffering from a shortage of foreign monies and foreign investment. Making it harder to buy foreign money, coupled with the requirement that the native currency be devalued, is a sure recipe for inflation. So it has proved. Since the Nigerian Naira was devalued in 1986, as a result of these IMF requirements, inflation has risen by more than 350%, with wages having risen by a mere 10%. Inflation on this scale naturally frightens away foreign capital once more. Internally industry finds itself in ever graver difficulties; imports rise steeply in cost, and it is much harder to export. Spending power within the economy is drastically reduced. Government subsidies to developing industries have to be withdrawn. Bankruptcies are rife.

The downward spiral yields domestic disorders in its turn. Corruption grows. Public funds are siphoned off and taken overseas by private citizens (since 1976, Mexico has lost $44 billion through this process). Short term expediences take the place of balanced long term plans; in Brazil and Ethiopia, borrowed funds have been used to buy arms. Nearly all third world countries have to borrow more money in order to service their existing debts. Thus not only can the necessary cultural planning not take place, the desperation of everyday life eats away at the traditional values of each of the impoverished societies, destroying the cultures which existed in more placid economic circumstances.

One further consequence of colonialisation has been the way urbanisation and transport systems have been developed. This too

has had a profound influence on the scale of the cultural problems third world countries face. Whereas in the advanced nations the capital cities have grown over time, as seats of government, centres of the national culture, business centres and repositories of much of the nation's wealth, the capital cities of colonised countries have grown suddenly, and without those important buttresses. Most have been created because they were simply convenient ports; Accra in Ghana, Lagos in Nigeria, Dakar in Senegal, Freetown in Sierra Leone, Bombay in India and Rio de Janeiro in Brazil, to mention but a few. They were all good collecting centres for exportable goods, and useful ports for importing and exporting also. In general, colonialists then built communication systems between that new capital and major collecting points (or production points) of the country's chief export.

The urbanisation and the communication systems were not therefore built in the service of the actual country and its citizens, but rather for the economic conveniences of the colonisers. The result has of course been that cultural provision has tended in the post-colonial period to be itself centered around the capitals and to transport itself along the colonial lines of communication. This means that in Jamaica most of the country's arts organisations are located in Kingston; in Uganda, they are in Kampala; in Nigeria, in Lagos. Away from the big ports and the collecting centres to which the railways run, there is little, if any, provision. All of this adds yet another dimension to the problem, for at present, in lean times, what few resources there are inevitably go where they will have some impact, and not to less accessible regions where there are no transport systems, no buildings and no means of making use of them. So, in Lagos there are more than fifty theatre companies, but in some regions of the country there are none. In Zimbabwe, one can well land in Harare and be impressed by the sophisticated and cultured lifestyle of the capital's residents; the cinemas, theatres, night clubs, luxury hotels are all reassuringly familiar to the travelling sophisticate; a short car drive out of the city however brings the scale of the cultural problem vividly home to the visitor.

For that city sophistication is recent, false, and gained at the expense of the majority of the population who generally remain not only poor and uneducated, but disadvantaged further by being cut off from their traditional pre-colonial cultures. Consolidation has

sharpened class divides, and though the poor have been disenfranchised fron their own histories, the rich and successful have been rewarded by being given access to the international cultural currency of success. In cities such as Harare, there is the Holiday Inn leisure lifestyle for the successful, and it is that which may impress the visitor. The visitor may not however have time to visit the settlements out of the cities, in lands which have had their historic significances stripped from them by exploitation of their resources. There may not be time to notice that the internal communications systems between peoples hardly exist, that most are unemployed, and that those that are in work are so exhausted after long hours spent travelling to and from work by wretched public transport systems, that all they can do is sleep. Nor may the visitor actually notice the crime, and the fear of crime which imposes an unofficial curfew in so many cities of the third world, for the Holiday Inn and its environs are well guarded. Certainly no tourist will see what many of the residents of the third world actually *do* in their leisure time - sleep, or, ritually, go off to makeshift bars close to their homes and drink themselves into oblivion. It will all look to the visitor as if the development is in as upward spiral. Here are the cultural amenities, duly bringing in the tourists, and setting proper cultural 'standards' for all the population 'out there'. In fact those centralised amenities, designed to put the visitor in relaxed and optimistic mood, can more properly be seen as part of a process of cultural colonisation of the most modern kind, a transaction by which the entirety of all the traditions of the third world country is traded for a small slice of the international tourism cake. (In the foyers of the international hotels in the new capitals a few indigenous art abjects are sold to the visitors.)

11.4: Current Patterns of Arts Patronage

In most developing countries arts patronage is dispensed beneath the broad canopy of 'culture'. There are few discrete *arts* funding bodies, and it is more usual to find units that have the responsibility for trying to promote a broad range of activities in, say, the performing arts, having to work alongside other leisure planners. The relative shortage of funds and of resources further complicates

the picture, for it is quite usual for such units, recognising their powers are limited, to concentrate for a year or so simply upon one kind of activity - to the inevitable detriment of others, and thus making continuity difficult to achieve.

Moreover in developing countries there is not that division between the performers and the providers which is the pattern in advanced countries. The government units are both; they themselves usually produce the plays, mount the exhibitions and so forth. Their programmes are set alongside programmes in other areas of recreation and sport because the units are themselves set within more general ministries, as we noted above - in Jamaica, the Ministry of Information and Culture; in Nigeria, the Ministry of Social Development, Youth, Sports and Culture; in Uganda, it is the Ministry of Sports, Culture and Social Development. The chosen programme for the year tends to be seen in a frame alongside the sports programme and so on, as being emblematic of the nation's achievements. Inevitably therefore such promotions are done according to what we called in the previous chapter the Glory Model rather than according to any ideal of the general welfare.

However, the notion of national glory is not the settled thing it may be in the older advanced countries. As different factions take over government so the perspective on the country's history changes and with it the desirable arts programme. The pressures of international creditors are also a factor. An arts programme produced essentially by government will naturally reflect the kinds of picture the creditors like to see. In particular military governments will tend to merge military control systems with cultural control systems, and national glory will seem to be synonymous with national military might. In the Greece of the Colonels, the governments arts administration department was merged with the military police. In Nigeria, there have in the past decade been three quite different expressions of cultural policy which have taken the form of military decrees. In Uganda there have been seven Ministers of Culture appointed within the last nine years.

Although such instability is plainly undesirable, it is hard to see how apeing the more settled arts funding systems of the advanced countries can be of much help. As we have noted several times in

this book, systems are not transferable from one cultural context to another. Some countries have compounded their difficulties by importing from Britain the notion that there must be separate bureaucratic structures for the arts and for education. What has not been imported is the long British experience in dividing their responsibilities. The result in Nigeria has been that research into the national arts and culture, publication of arts handbooks, the collection of national treasures are all activities subjected to control by two overlapping bodies which have responsibilities for these matters, the Visual, Literary and Performing Arts Department in the National Council for Arts and Culture, and the Federal Department of Culture and Archives. The labyrinth of bureaucratic paths which an applicant for support needs to tread, or the complexities involved in deciding 'who does what' in any new task can readily be guessed at. The overweighted bureaucracies of the advanced nations are thus on occasion replicated in the countries of the third world.

In conclusion, it can be seen that in spite of the massive economic and social problems faced by the developing countries, a clear cultural policy is wanted, and indeed the will to create one exists in most countries. The very size of the problem has forced from some governments cogent and far-sighted responses. For example, although governments of advanced countries find it convenient to evade the question of what 'the arts' actually are, the governments of some countries of the third world have been forced actually to list the constituent parts of their emergent national culture. There exists such a list in Zimbabwe, for instance, and its existence (which can never be absolute, and is subject to constant modification) makes coherent and sensible planning much more likely. It also reduces the likelihood of such countries taking refuge in the empty pieties of 'arts policy-making' as often practised in the richer countries. Much of the time and effort spent in producing 'arts strategies' in the lusher pastures of the advanced nations could with advantage be used in resolving the much starker problems of the third world, where platitude and elegant metaphor cannot be accepted as a reasonable 'policy'.

Some people will of course say that countries faced with hunger and starvation, and with dreadful problems in housing, in the provision of work and in transportation, should not concern themselves with luxuries such as arts policies. To which the reply

must be that it is the decades of flabby thinking in the advanced countries that have reduced that dialectic about how to live, which is at the heart of the formulation of any arts policy, into an amusement for the well-heeled and privileged. In any civilisation which has not gone flabby it is a *necessity*. Culture is not something taken after the dessert, but something which shapes the way you grow your corn and earn your bread. Third World countries need to restore the civilisations (and the patronage systems too) which colonialism destroyed; they need to shape a new order out of their present cultural chaos by creating systems which allow that necessary dialectic that we discussed in the first chapter. When the people are fed and *when they have something of their own culture restored to them*, at *that* stage direct government arts policy-making may be rather less necessary.

THE FUTURE

12: The Scale of Arts Policies

It is useful to summarise the chief characteristics of bad or useless arts policies. Some, if not all, of these characteristics can be found in a majority of the 'policy documents' that have been produced in the English-speaking world during the last fifteen years.

12a: The aims and purposes of the 'policy' are extrinsic to the creation and enjoyment of art. The arts are 'used' as a means to a social end, and the acceptability of the policy rests upon the statement that a particular (and generally inoffensive) aim is in view and the rather fuzzier assumption that the arts can be censored, stifled or 'supported', according to how well they seem to be promoting the social or political objective. The plain difficulty with this is that it assumes that the relationship between works of art and social forms is clear and predictable - that plays highlighting injustices done to the black population will increase awareness of black problems and will lead to a change for the better in the way black communities are accepted, for instance. There is no evidence, from any realm of research, that any such simple relationship exists, and the likeliest result from such policies is confusion and artistic anarchy. It is of course right and proper to encourage and to enjoy the work of black artists, but to try to form a system which has as its *starting point* the aim of supporting forms of black political values and which attempts to 'read back' into the artworks the support or otherwise of those chosen values will be impossible to create and arts bureaucrats will render themselves ridiculous in the attempt.

12b: The resources offered to implement policies are plainly inadequate to the task. Although the policy aims may be very grand - harmony between minority groups, full participation in the artistic life of the country by all citizens, the resurrection of the inner cities,

whole countries sustained by incoming tourism - many policies offered at the present time offer pitifully inadequate resources, and pitifully little awareness of the kinds of resources that would be needed were the objectives to be even distantly realisable. To achieve anything like the 'full participation' in the national arts that many arts policies call for would in many countries mean a total reform of the education system, an entirely new transport system, a much more directed communications system, a building programme of great magnitude, reinvestment in training programmes on a scale no economy could possibly sustain, and a degree of direction within leisure time that many people, since ancient Athens, have found unacceptable. Although it is convenient for governments to say that grandiose effects flow from the promotion of the arts, it may usually be suspected that governments find that a way of evading wider and much more difficult responsibilities. If a charitable donation to 'the arts' can be presented as a serious attempt to deal with the 'needs' of the inner cities, why then bother with the housing, the jobs, the schools, the hospitals, the buses and all the rest of the expensive wants of the inner city population?

12c: The metaphorical language in which the policy is couched implies that economics matters more than art. The policy will tend persuasively to redefine all the processes in the creation, production and distribution of art so that 'real' economic language of 'the market place' can be applied, and used as a controlling mechanism. Creation of art will become (in the words of the Arts Council of Great Britain) partly a matter of 'minimising overheads' and carrying out 'audits of current managerial practice'. Art is here valued for the commercial opportunity it presents, not for the benefit in itself. For example, the Director of Leisure Services in the English town of Sutton says of his local library, 'Private enterprise comes in and pays good money to take a gallery, a part of a wall, or an ad in our *What's On* newspaper. Five thousand people who read have to be attractive to someone.' In other words the mere fact that five thousand people read books is not in itself of much importance; they are apparently not an attractive bunch in the eyes of the Director of Leisure. He would prefer the walls to be covered with commercial advertising rather than bookshelves. Because

commercial folk 'come in', bringing reality in their wake, and pay
good money - that's the only reason for tolerating five thousand
readers in the town library.

*12d: The policy constantly alludes to arts management practices
as if they are an entire substitute for art.* Bogus policies will of
course blur many important distinctions (between 'devolution' and
'decentralisation', between 'development' and 'change', between
'enterprise' and 'initiative', and will use language smearily *and*
pompously. In the midst of such documents however one pervasive
habit has to be remarked upon. It is that alterations in bureaucratic
practice are described as if they are changes (or 'developments')
in *art*. At the present time the English-speaking world abounds in
plans, policies and strategies which pronounce their aims to be
little short of cultural revolution, but offer only modifications in
bureaucratic procedures, in managerial definitions, or in
bookeeping practice by way of illustration of the nature of the
desired change. In this respect, by far the worst offender was the
British Arts Council's ill-fated *Glory of the Garden*, produced in
1983. It affected to be a 'strategy' for a decade in the arts, but it
suggested, behind the verbiage, nothing but slight modifications in
the way arts bureaucrats handled grant aid. It purported to be about
the 'development' of the arts in the regions, but it talked only of
modifications in the regional arts bureaucracies. The result was
that a great deal more bureaucratic activity went on; more papers,
more reports, more consultancies, more strategic 'planning'. In its
turn that activity was constantly describing itself in its own reports
on its own bureaucracy as developed in the *arts*.

*12e: In support of immediate political ends, the policy takes a
highly selective view of the past*. A political ambition, such as that
currently held by the Arts Council of Great Britain, which has now
announced that it is *the government's means* of supporting the
arts, will impel writers of policy to ignore inconvenient history and
will impel them to re-order the remainder of it so that it seems to
accord with desired policy changes. The British Arts Council for
example, which wants to promote what it calls 'enterprise' in the
arts has to gloss over the fact that the term may not mean very
much and give it a sharp and positive connotation by contrasting

the past (when the arts were apparently *un*enterprising) with a vision of the future. Accordingly at every opportunity it says or implies that, until now, the arts have always relied on a feeble welfare state collectivism, have never been businesslike, have never marketed their 'product' properly. Yet that is by any standards simply untrue. The Arts in Britain have (as we saw in our historical survey) frequently been commercially successful. The majority of the arts in Britain have never relied on subsidy *and still do not*. The list of entrepreneurs in the arts world is at least as impressive as any list of washing tycoons, stock market whizz kids or soap powder magnates. The notions that in Britain artists and arts organisations have until now battened feebly on to state welfare is a monstrous and degrading lie, and when it appears so regularly in policy documents and in 'strategic' papers must call into question the motives of the policy-makers and the validity of anything else their policy documents might argue for. The future cannot be on a deliberate misreading of the past.

When they are afflicted with faults such as these, arts policies are not 'better than nothing'. There are innumerable instances in recent years when nothing would have been greatly preferable to the confused, costive and mean policy documents that governments, political parties and both national and state or regional governments have produced. For arts policies should only be produced when they are wanted - to produce them in other circumstances shows a desire for cultural control, and generally, a hostility to artists and art in those producing them.

Arts policies are indeed usually wanted in the early years of a country's independance when colonial powers have falsely welded together many disparate cultures and have generally so distorted the country's avaliable resources that a coherent view has to be taken both of how and *why* people are going to live. Further *resources* that they have, for a time, to be reshaped and managed according to an informed view of the traditional cultures. Most unnecessary, unworkable and even dangerous policies in recent years have been created on the assumption that the only real 'resource' worth having a policy about is state subsidy (or 'funding' as it is lazily called). In general, specious policy statements will be based upon some minor proposed change in the way state

subvention is managed, and the other resources of buildings, people, creativity and artistry and above all the *past* are ignored, or denigrated. The future (it is worth repeating) cannot be planned upon a misreading of the past.

Nor can arts policies, even when they *are* genuinely wanted and not just window dressing for otherwise brutal regimes, be attended to with respect, or acted upon, unless they demonstrate that they understand what the arts *are*. That means an understanding of the cultural traditions which give each of the arts their significance, and an understanding of the necessary critical debate that gives them value. To understand any of the arts demands both a full knowledge of traditions, and participation in the necessary critical debate. It is the British Arts Council's massive (and often willed) ignorance of the cultural traditions of Britain, and their uneasy confusion of critical debate with a secretive form of managerial appraisal that ultimately invalidates what they do, and makes them a force for mediocrity. They are, in the broader sense of the term, *illiterate*, and the effect upon the arts criticism of their vacuous and flaccid pronouncements is enervating and destructive.

12.1: Arts Policies
Not all is lost, however, and there are sufficient examples, ranging from Northern Arts Ltd. in Britain to the State of Melbourne in Australia, of policies which put back at their heart the inherent value of the arts, which insist that they are just worth having in themselves and not for their supposed effects, and examples too of policies which recognise that there must be free critical debate establishing the values and not a government-imposed bureaucracy, for there to be hope that the dark winter of 'the arts industry' may be passing. The better examples of arts policies tend still to come from the developing countries, where policy-making is less obfuscated by the mechanics of political accommodation, and in which the language has not yet acquired that thick overlay of accumulated metaphor which renders phrases such as 'arms length principle', 'artistic development' or 'peer group assessment' so flabby and tendentious.

To be *coherent* arts policies have to pay attention to each of the following categories. First, they must recognise and

acknowledge the entirety of the traditions which give all of the arts meaning. Second, they must then fully describe all the resources which exist in the creation, conveying, participation in and spectatorship in the arts. Third, they must analyse the distortions which prevent a desirable creativity, prevent the arts being conveyed to those who want them, prevent people participating in arts activities and prevent people from being spectators at the arts. Fourthly, policies must propose the means of correcting that distortion.

The task is, as will be readily appreciated, enormous in scope. For the true arts policy will, when formulated, seek to employ a full range of resources available to governments - educational resources, transport resources, health resources, and resources in social welfare - and it is therefore likely always to be both broad in scope and yet immensely detailed in the mechanisms it discusses. The style will vary - ultimately policies will be predominately prescriptive, descriptive or reactive in nature - and emphases will change, but, however particular the areas with which the policy may finally concern itself, account must always be taken of the entirety of what is meant by the arts - *all* those activities, *all* those constructs which give meaning to our lives and from which we draw pleasure and benefit.

Those many 'arts policies' which are concerned with the immediate manipulation of state money, or are concerned only to offer a fashionable gloss on cultural history which presents the government in a reasonable light, or which are concerned only with the maintenence of a few favoured arts organisations, or with the response to an immediate crisiis, are merely bureaucratic memoranda - sometimes useful, but ultimately of no particular significance. The scope of the true arts policy is much greater. It exists because it is wanted, not because some state organisation decides that it is useful to review management practice. It expresses something of the spirit of the times and of the character of artists and people. It is not a piece of governmental bumf that can easily be applied in another country at another time. It will be less concerned with the purposes of the arts, and with their supposed effects than with their continued existence. And, right as its heart, it will be offering an answer to the question which the Ancient Greeks knew was the most important question that could

be asked; how should the state so organise itself that its citizens may best live their lives?

12.2: Coherence in Policy-making

No arts policy can be of the remotest use if it is *too* diffuse and bland - if it consists of pieties about the art being 'the storehouse of the nation's treasure', and calls vaguely for 'a climate of support'. Nor can a policy be coherent if it concentrates upon too narrow an aspect of the complex arts world.

The faults outlined at the beginning of this chapter tend to be symptoms of both afflictions. Much that is put out as fashionable 'policy' nowadays tends to leap from the most dazzling pronouncements about the universal values of 'the arts' to discussing how a few favoured arts organisations can be properly 'funded'. There is no real link between the two things, and both are inadequate notions. The quality of life is not improved by the arts, it *is* the arts. And maintaining this Orchestra or that National Museum, this Gallery or that Theatre Company by itself does nothing for 'the arts'. Arts policies must be coherent; their authors must fully understand the nature of the arts they are supposedly supporting.

By increasing the grant in aid to the Royal Shakespeare Company, or by improving its 'efficiency' in production, you do not necessarily help the performance of Shakespeare in Britain at all. Offering a performance of a play on the RSC stage is less than a half of the event that allows us to speak of artistic excellence; the rest of the equation is a compound of literary and theatrical tradition which renders the performance coherent, and the attendance of an audience that is enabled to attend and to understand and draw benefit from the performance. In other words, if we coherently determine that we are going to maintain excellence at the Royal Shakespeare Company's performances, we must look to our schools, our libraries and our amateur dramatic societies, so that an audience comes with the ability to draw from the presentation the keen enjoyment which is their heritage.

The most disabling argument against the view that 'the arts' must everywhere be treated as 'an industry' is that it is simply incoherent and ultimately self-defeating, because the arts which

are created, packaged and promoted simply for their immediate commercial value will rapidly lose their other more important values, and become both meaningless and worthless. The tribal woodcarver, asked to produce objects for the tourist market, will soon forget why certain insignia were carved upon the spoon or upon the boomerang - and the objects produced, lying in the display cabinets of international airports, will in time seem meaningless and therefore worthless even to gullible tourists. The 'national dance company' which is kitted out in a tourist-trade version of 'national costume' and which learns a hybrid routine which seems vaguely 'folksy' to tourist audiences will in time be lost in a hinterland between their own peoples and an increasingly blazé tourist market. In a developed country, if government money is drawn out of the arts education in schools, if local libraries are denied purchasing funds, and if amateur groups can no longer use their local community halls cheaply to rehearse plays, to hold choir practices or to hold poetry readings, then, no matter how much 'investment' may be made in 'the industry' it will continue to lose its audience, its meaning and its importance; it makes no sense at all to praise the high standards of artists who are simply shouting into a void.

Policy-makers have constantly to remind themselves just how much the language of arts debate is weighted and constricted in nature. In Britain the creative life that gives meaning to most people's lives, and the essential dialogue that goes on and forms our contemporary common sense, takes place in organisations that are hardly mentioned in cultural 'strategies' and in places at which our arts bureaucrats glance only in passing scorn - in Women's Institutes, in pubs, in Working Men's Clubs, in conferences, in Townswomen's Guilds, in back yards and gardens, in kitchens and village greens, caravan parks and national parks, in street markets and discos, Blackpool and Aberdeen, the golf course and the river bank. The language of arts bureaucrats denigrates most of what it is to be British, by overweighting the importance of what is happening in a tiny segment of our national culture - the public presentation of subsidised art. Yet 'standards' should not be applied simply to the on-stage competence of, say, the Royal Shakespeare Company, but to the degree to which the population at large enjoys watching, reading, acting in Shakespeare's plays

and the entirety of the drama heritage. Literature in Britain likewise should not be judged by the qualities of the Booker Prize winner alone, but by all that is being written, read, enjoyed and treasured by the whole population. 'Art' does not exist only when a tourist has paid to view some properly-accredited art treasure, but exists in a million fleeting ways when the creative self is engaged. I am not indulging in 'Art' when I buy a poetry book but when, exercising the dog or walking the streets, I recall and take pleasure in a poem, or, much more rarely, have a poetic thought. The language of current arts policy-making, by pretending that the economics of arts markets represents all that is valuable, is itself a disfiguring handicap to real thought about the arts.

There is, usually, still more to be learned about the cultural life of a region, or even country, from walking its streets, reading its newspapers and simply looking and listening, than from reading its arts policies or its cultural strategies. The exception is in some developing countries, some regions of the world with fresh new forms of local government service and in the advanced nations there are exceptions after some major social upheaval. For the most part, however, one reads in arts policies only a kind of kindergarten hymn to a species of 'art' which is all things bright and beautiful, which never has and never could exist - a saccharine doggerel which hides the ugly face of the bureaucratic bully.

> Now though perhaps nobody knew it, it was ugliness which betrayed the spirit of man, in the nineteenth century. The great crime which the moneyed classes and promoters of industry committed in the palmy Victorian days was the condemning of the workers to ugliness, ugliness, ugliness: meanness and formless and ugly surroundings, ugly ideals, ugly religion, ugly hope, ugly love, ugly clothes, ugly furniture, ugly houses, ugly relationship between workers and employers. The human soul needs actual beauty even more than bread.

It is perhaps asking too much for our bureaucrats to feel and to think with the quickness and life of D.H. Lawrence. But it is sad that in the name of 'the arts' they so often help to spread the ugliness which he saw as the enemy of a well-lived life.

Appendix: Dictionary of Bureaucratic Terms

The following is a short list of some of the terms which have peppered 'Arts Policies' in recent years. It is not of course complete - the ground is shifting all the time - and does not deny that each of the following words can be used perfectly properly. In many Arts documents however they are not so used. Less evasive alternatives are suggested for trial.

Access
Used in a blurred way to cover all the processes involved in education, transport, economics, marketing and design which bear upon people taking part in arts activities. One of a string of words which have meanings in computerese and hence seem to be macho and managerial ('The Access Planning Group').

Try Availability, Eligibility, Entrance, Suitability, etc.

Arts
As in 'The Arts'. Almost always misused when some grandiose and ultimately untenable claim is being made. The vague implication is usually that the economic and creative processes involved in the theatre, in break dancing, pottery, opera singing, alternative cabaret, public sculpture and piano playing are all roughly the same (see 'Industry' below). In practice the boundaries of what seems to be discussed as 'The Arts' vary from sentence to sentence. The following appeared for example in the British Arts Council's An Urban Renaissance:

> The arts can make a substantial contribution to the longer-term revitalising of depressed urban areas. Theatre, music and the visual

157

arts - and the facilities for their enjoyment - are essential ingredients in the mix of cultural, environmental and recreational amenities which reinforces economic growth and development. They attract tourism and the jobs it brings. More importantly, they can serve as the main catalyst for the wholesale regeneration of an area. They provide focal points for community pride and identity. Equally importantly, they make a contribution to bringing together communities that might otherwise be divided.

Try Break Dancing, Piano Quartets, Graffiti Art, Honiton Lace-Making, Reggae, etc.

Assessment
Bureaucratic check on institutional conformity. The word used to mean a critical appreciation of art, but now refers to managerial procedures and takes place whether or not any art is being produced.

Try Management check.

Community
A warm burr which denotes nothing except a furry construct in the writer's mind, but has all kinds of cosy and gentle connotations. The word is almost always used as an evasion, because the author does not want to be seriously challenged. ('The arts increase community pride and develop community identity.')

Try Inhabitants, Citizens, Voters, Community Tax Payers, Grown-Ups, Locals, etc.

Challenge
A heroic term usually used to describe some management objective which is either inherently ridiculous or plainly undesirable. The muscularity of the term frequently hides a flabby concept. ('Challenge Grant', 'The Board faced an exciting challenge when the building was condemned.')

Try Task, Job, Problem, etc.

Corporate
Grandiose term which is usually used to puff up a temporary agreement (as in 'Corporate Strategy') over publishing a glossy report, but sometimes used in a more ominous way to brush aside queries and worries about secret deals (as in 'Corporate development plan for the region').

Try Joint, Masonic, Secret, Diplomatic, etc.

Demand
A word which normally applies to the whole range of consumer preferences but which is usually used in a highly selective way by arts bureaucrats to point up the interest segments of the public may have in the subsidised arts. This special sense of 'demand' is not 'met', but 'fulfilled' by bureaucratic action, i.e. the demand is fully acknowledged only *after* the bureaucrats have acted, as in this piece from the British Arts Council's Annual Report No. 42 (1986/7):

> Financially 1986/7 was not an easy year for the arts. Many arts organisations were staving off financial disaster, not because of lack of demand, but because the essential core funding was no longer enabling them to fulfill that demand.

('fulfill' was printed with its American spelling.)

Try Wants, Wishes, Desires, Interest, etc.

Development
A word which has a perfectly acceptable usage in post-colonial countries, where its associations are entirely honourable. Arts bureaucrats however either use it simply to mean 'bureaucratise', or in the more shady sense of 'House Developer' or 'Development Agency' - agencies primarily interested in profit use the term as a shield.

Try Alteration, Change.

Diplomacy
Colonialism, as in 'Cultural Diplomacy'. Usage of the word in the context of the arts draws the business of foreign tours by art and artists into the realm of military strategy. We are hence a short step only from national dance companies being on the agenda of disarmament negotiations.

Try Exports, Imports, Sales, etc.

Efficiency
Dependable mediocrity. The word slips into planners' talk when it is proposed that bureaucratic minds should set the parameters within which the creative mind should work, and should determine in advance what the public 'needs'.

Try Rigid forward-planning.

Enterprise
A word used to bestow the right-sounding praise upon activities which conform to the right-wing notion of individual responsibility etc., but in practice usually applied to sordid acts of bureaucratic collectivism which involve the tax payers' money. ('This Art in Public Places scheme is funded by the Regional Arts Association, the local Boroughs and local industry and is a fine example of the new Enterprise in the Arts.')

Try Conformity, Institutional Behaviour.

Facilitator
Slyly insinuates that the agency involved is taking a quiet back seat and behaving neutrally, but in fact usually screens a pushy desire to shape, control and boss everybody about. ('We shall act as facilitators, bringing together national developers with appropriate arts organisations.')

Try The Big Cheese, Manipulator, Planning Chief, etc.

Funding
A word which used to mean that one had sufficient monies invested to live off the interest. (Remember Lady Bracknell's approval of John Worthing's fortune.) Now used to mean the monies that come from all neo-governmental sources - grants, loans, gifts, awards, payments, prizes - and which are the essential tool in the bureaucratic control system. In spite of the fact that many theatres, orchestras, galleries, museums, publishing houses, cinemas, musicians and entertainers sustain themselves perfectly well in the private sector, 'funding' is mysteriously held to be 'essential' for artistic centres of excellence ('essential core funding'). The smeary use of the term puts a stopper on serious discussion about which buildings, organisations and artists do require financial support, and at what times.

Try Finance, Money, Cash, etc.

'Garden'
The most obvious of a whole range of horticultural metaphors now crassly used by the British Arts Council in particular, but of honourable ancestry (see Coleridge, *Biographia Literaria*). The mataphors often do not actually refer to anything precise at all. ('The Glory of the Garden', for example, a 'strategy for a decade' produced half a decade ago by the Arts Council, might have been referring to the subsidised arts, Britain's entire arts world, Britain's heritage in the arts, the Arts Council itself, the 'new' systems discussed for state financing of the arts, the Regions, the artistic Centres of Excellence, or none of these things.)

Try Bureaucracy, Market, etc.

Industry
Hard-nosed term applied with numbing imprecision to the myriad different economic processes involved in the creation, marketing, sale and participation in all of the different arts (see 'The Arts' above). Capable of endless mis-use in a slightly crazed manner reminiscent of bar room talk by rookie managers, as in 'The Box Office is the managerial chalk face in this industry'. Term glosses over both the individuality and the extreme competitiveness which

are, as everyone knows, the most obvious characteristics of the arts worlds, and it implies that all painters, actors, singers, sculptors, dancers, video film makers, designers, instrumentalists, photographers and novelists are somehow serving the same shift on the same production line, sweating to reduce the balance of trade deficit.

Try Economic processes.

Inflation
Something which happens to the rest of the economy and which is asserted to have consequences for 'the arts world', which is *never* a part of the cause of it. It is usually mentioned in connection with a misunderstanding of the work of the American economists Baumol and Bowen, and thought to be a good reason for governments to step up their financial support of arts bureaucracies. In general arts organisations feel that it is improper to increase prices of admission, as others do in inflationary periods; although habitués of Professional Boxing, Football, Theme Parks, Gourmet Restaurants, Sports Centres, Public Houses etc. are all willing to go on paying more for their pleasures, it is felt that lovers of 'The Arts' are more fickle, and have to be bribed to enjoy their fancy by seat subsidies.

Try Price increases.

Investment
A trendy new word, used by left-wingers as much as by monetarists, for Grant Aid. The implication is that untold benefits will result from giving the money now it is called that, whereas formerly it was just blocking up a financial leak.

Try Financial help.

Needs
An old lefty word which has been carried over into the new brutalism because it is still useful for all bullying bureaucrats. It implies that people have desires, unknown to them, which can be somehow discerned and registered by state-paid bureaucrats ('real

needs', 'seeking solutions to percieved need and not just to articulated demand'). Of course it is true that people don't know whether they want any kind of art until it has been created and offered to them, and it is therefore true that experienced arts administrators have inevitably to try to second guess these wants as they develop arts programmes. But it is also true that even after wants have been demonstrated it takes a long time, and is a considerable step, to say that the public that wanted the art also *needed* it. That is a profound assertion. And it is therefore worth emphasising that the bureaucrat has not yet been born who can second guess what people's *needs* are, or will be.

Try Wants, Desires.

Negotiations
Arrangements to find a face-saving formula to dress up circumstances imposed from above. ('Following negotiations with the Councils in the area, a formula was adopted for regional development.')

Try Arrangements, Accommodations.

Organisational
Vaguely businesslike term usually used to disguise the fact that a process which was previously concerned with aesthetics, morality, critical discourse or artistic excellence is now to be seen as purely managerial, concerned only with economics and business. As in 'Organisational Review'. (See 'Efficiency' above.)

Try Financial, Business, Economic, Profit-seeking.

Partnership
Buddy-buddy term designed to present the fact that long-term adversaries have been bribed to do something together, for the look of the thing (as in 'The partnership of the Arts Councils and the Regional Authorities') or sometimes, with a greater vacuuity, it is used to give a spurious sense of fireside communality in 'The Arts' (i.e. 'A Community Partnership'). Almost always refers to

something temporary, deeply suspect and one in which somebody or other will have their fingers in the till.

Try Temporary deal.

Plan
Plans for the arts are almost invariably plans for the arts bureaucracies - usually plans that involve living well, researching for 'reports', travelling overseas on fact-finding missions, offering well-paid advice to colleagues in distant locations, consulting with other bureaucrats over long lunches and drafting further plans which involve more bureaucrats writing more plans, etc.

Try Bureaucratic activity.

Regeneration
Heavily publicised, and heavily government-financed rebuilding of some chosen area. It usually involves, in the case of 'inner city regeneration' moving out the inconvenient poor, disabled, ethnic minorities, etc. and replacing their dwelling places with hotels, wine bars, shopping malls, heavily guarded recreational areas, saunas, travel agencies, tourist craft shops and perhaps one heritage museum, or a gallery or a tasteful concert hall. The dispossessed look on from their slum suburban tower blocks with dismay. Local crafts are on sale in the hotel foyer shops to prove to the tourists that they have really been there.

Try Exploitation.

Strategy
A military term for 'plan', much used by keen-eyed arts officers in the field. It usually refers in fact to a series of nondescript axioms bound together in a glossy little book ('The strategy is to develop the arts to attract business interest and move on to positive regeneration of the area' kind of thing), all of which are so much guff and useful only in hiding the ackward fact that the arts officer in question probably can't tell poetry from prose and wouldn't recognise good music even if he or she had time to listen to it. It validates the kinds of things done by arts officers who by

temperament and ability would be better working for an insurance company.

Try Young managers' phrase book.

Tourist
When some impressive statistic is needed, 'tourist' and 'tourism' refer to everybody away from home - conference-goers, holiday-makers, day-trippers, family-visitors, hikers, bikers, caravanners, business travellers, gypsies etc. (Such a use is in 'Tourism is Britain's second-largest industry.') However in arts strategies plainly it has a much narrower meaning. It does not include holiday-makers, nor hippies visiting Stonehenge, nor football supporters visiting an away game, nor the millions visitiwng outdoor parks with their families. A tourist is somebody who visits the government-approved arts, and, in this definition, preferably somebody who stays in a 'regenerated' area, spending in the tasteful crafts shops, preferably in dollars or by internationally accepted credit card. By their purchasing preferences 'tourists' sanctify what governments nowadays describe as 'the arts', for each term depends upon the other. The arts attract tourists. You become a tourist by spending on the arts.

Try Visitor, Traveller, Temporary Resident, Immigrant, Holidaymaker, etc.

Bibliography

The most sophisticated account of the delicate interaction of the arts and the market place is in J-C Agnew, *World Apart: The Market and the Theatre in Anglo-American Thought* (Cambridge University Press, 1986). Historically, the British scene is well described in M. Foss, *The Age of Patronage: The Arts in England 1660-1750* (Hamish Hamilton 1972, reprinted by Bristol Classical Press 1988 under the new title *Man of Wit to Man of Business*), in R. Porter, *The Eighteenth Century* (Penguin, 1986) and J. Minihan, *The Nationalisation of Culture* (Hamish Hamilton, 1977). The American picture is described in detail by H. Banfield, *The Democratic Muse* (Twentieth Century Fund, U.S., 1984); its abuses are described at length in M. Mooney, *The Ministry of Culture: Connections Among Art, Money and Politics* (Wyndham, N.Y., 1980), and there is interesting material in the still-radical proposals contained in H. Krawitz and H. Klein, *Royal American Symphonic Theatre* (Collier Macmillan, 1975).

P. Jones, *The Consumer Society* (Pelican, 1965) offers a critique of the workings of American capitalism which is relevant to the current debates about the arts 'going into the market place' and becoming 'the Arts Industry'. Of all his valuable texts the essay 'Advertising: the Magic System' in Raymond Williams' *Problems in Materialism and Culture* (Verso, 1980) is probably the most relevant, and there is a useful, light-hearted look at the curious phenomenon of lucrative 'tourism' in J. Feifer, *Tourism in History* (Stein and Day, U.S., 1986).

Particular examples of highly successful arts entrepreneurship from the past are nowadays well-worth reading, before we are all brainwashed into believing that until the 'real world' of business was brought in to help nobody ever ran a theatre, a gallery, a circus, a concert hall or anything else in the arts profitably and well. One might get a sense of how much 'the real world' of business owes

to the skill of arts administrators of past ages by reading, for example, C. Bode (ed.), *P.T. Barnum: Struggles and Triumphs* (Penguin American Library, 1981), R. Fawkes, *Dion Boucicault: A Biography* (Quartet, 1979), G. Speaight, *The Life and Travels of Richard Barnard: Marionette Proprietor* (Society for Theatre Research, 1981), A. Hyman, *The Gaiety Years* (Cassell, 1979), D.G.C. Allan, *William Shipley: Founder of the Royal Society of Arts* (Scolar Press, 1979), B. Stoker, *Henry Irving* (Heinemann, 1911), Charles Cochran, *Cock A Doodle Doo* (Dent, 1941) and Cyril Bertram Mills, *Bertram Mills Circus* (Ashgrove Press, 1985). In their different ways they will give some indication of various kinds of successful entrepreneurship in commercial realms and examples of initiatives in the public sector, long before the present forays into hard-nosed market realism.

Accounts of the growing involvement of governments in the arts and entertainments can be found in Richard Fawkes' admirable account of the government-sponsored entertainment of the British and American armed forces during the Second World War, *Fighting for a Laugh* (Macdonald and Jane's, 1978). Useful companions in pondering that field are Asa Briggs' series of books on the birth and history of the BBC, and George Perry's account of Britain's best-known film production company, *Forever Ealing* (Pavilion, 1985). A longer perspective on state involvement in cultural planning comes in the best history of the political birth of the National Theatre, J. Elsom and N. Tomalin, *The History of the National Theatre* (Cape, 1978). Casting the net wider, people who worry over the growth of 'Festivals' and their place in the new economic strategies will find much food for thought in a closely allied field, the financing of the Olympic Games, pungently described in A. Tomlinson and G. Whannel, *Five Ring Circus* (Pluto Press, 1984). The more serious economics of third world development are usefully introduced in Margaret Mead (ed.), *Cultural Patterns and Technical Change* (Mentor, U.S., with UNESCO, 1985).

Confusions in past British arts policies are set out in straight-faced detail in H. Baldry, *The Case for the Arts* (Secker and Warburg, 1981), and more polemically in my own *Managing the Arts? The British Experience* (Rhinegold, 1986). That book argues that students looking for a prime example of arts

bureaucrats' gobbledegook need look no further than the Arts Council's own *The Glory of the Garden*. (This 'strategy for a decade' which splendidly confused decentralisation with devolution, is undated but from internal evidence it is possible to deduce that the decade in question was 1984-1994.) A revivifying contrast to the portentious platitudes of that policy document may be found in any of the writings of the late Professor Titmuss. In particular, any policy-maker should read R.M. Titmuss, *Social Policy: An Introduction* (Allen and Unwin, 1974).